# NORTH CAROLINA RIVERS

# North Carolina Rivers

## Facts, Legends and Lore

John Hairr

Published by The History Press
Charleston, SC 29403
www.historypress.net

Copyright © 2007 by John Hairr
All rights reserved

*Front cover*: The Linville River cascades over Linville Falls.
*Back cover*: The Uwharrie River flows through the Uwharrie Mountains, a range of extinct volcanoes in central North Carolina.
Unless otherwise noted, all photos are courtesy of the author.

First published 2007

Manufactured in the United States

ISBN 978.1.59629.258.1

Library of Congress Cataloging-in-Publication Data

Hairr, John.
North Carolina rivers : facts, legends, and lore / John Hairr.
p. cm.
Includes bibliographical references.
ISBN 978-1-59629-258-1 (alk. paper)
1. Rivers--North Carolina. 2. North Carolina--Description and travel. 3. North Carolina--Geography. 4. North Carolina--History, Local. 5. Rivers--North Carolina--Folklore. 6. Folklore--North Carolina. 7. Legends--North Carolina. I. Title.
F262.A17H35 2007
975.60096'93--dc22
2007017135

*Notice*: The information in this book is true and complete to the best of our knowledge. It is offered without guarantee on the part of the author or The History Press. The author and The History Press disclaim all liability in connection with the use of this book.

All rights reserved. No part of this book may be reproduced or transmitted in any form whatsoever without prior written permission from the publisher except in the case of brief quotations embodied in critical articles and reviews.

# Contents

Introduction                                                7

Chapter 1: Rivers of North Carolina's Sounds               13
Chapter 2: The Cape Fear and Its Tributaries               51
Chapter 3: Rivers of the Mississippi Watershed             71
Chapter 4: The Pee Dee                                    103
Chapter 5: The Santee                                     125
Chapter 6: The Savannah River Watershed                   143
Chapter 7: Coastal Rivers                                 149

Bibliography                                              157

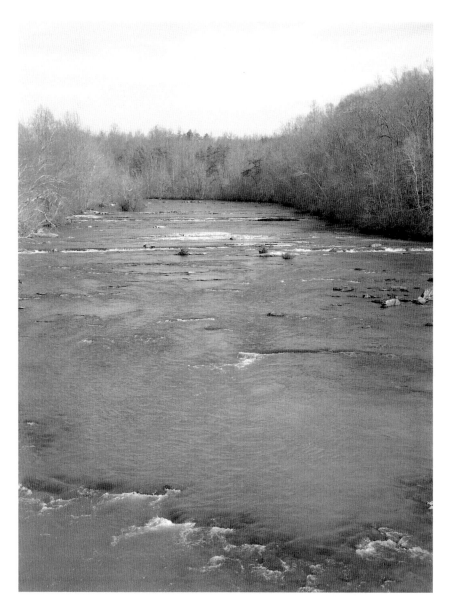

The Mayo River.

# Introduction

What is a river? Rivers are different things to different people. According to the *Oxford English Dictionary*, a river is a "copious stream of water flowing in a channel towards the sea, a lake, or another stream." But rivers are so much more than that. To some they are watery highways upon which people have traveled for generations. There are people who look at rivers as a source of kinetic energy to power industry, from humble gristmills to mighty hydroelectric turbines. Some see rivers as a virtually endless supply of drinking water, while others might look at the very same stream as an efficient and convenient place to dispose of waste.

Down through the years, people in North Carolina have utilized rivers for different reasons. To the Native Americans, the rivers were a source of food. They built weirs and fish traps in the rivers to catch fish, or probed the muddy riverbanks for mussels and shellfish. Although people today continue to look to the river as a source of food, none rely on them to the extent the Indians did.

In the earliest days of settlement, rivers provided the easiest means of entrance into the vast hinterland of the continent. In what is now North Carolina, explorers such as Arthur Barlowe and William Hilton utilized some of the state's most famous rivers as they probed inland from the sea. Settlers soon followed these brief forays, staying longer and building settlements along the navigable rivers and streams. Boats and canoes traveled the rivers looking for suitable places to settle.

# Introduction

For nearly three centuries, the rivers provided an outlet to the sea for the products of the field and forest. Rafts, bateaux, steamboats, canoes, perriaugers, tugboats, skiffs and just about every other craft imaginable have plied the state's waterways transporting commodities as diverse as timber, naval stores, dressed animal hides, diesel fuel and fertilizer.

Today in North Carolina we look to rivers primarily as a source of drinking water. As the population continues to expand, it is vital that we have renewable sources of clean drinking water that are safe from contamination. To accomplish this, several dams and reservoirs have been built along the rivers of the state. Some reservoirs that were designed primarily for flood control are now being utilized by towns and cities as a ready source of drinking water.

This book is an attempt to compile into one source information about the various rivers of North Carolina. This is not a technical treatise on hydrology. Nor is this a collection of first-person accounts of river descents and thrilling escapades on the wild waters of our state. Although I was tempted to include several of these, I decided to hold stories about my river adventures here in the Old North State for a future volume.

This book gives a general overview of each river, telling where the respective rivers begin and end, and gives some details about important landmarks. Some historical episodes are included, telling about towns, river ports and other interesting events. Finally, the origin of the name of each river is given, if it is known. I have been able to track down the origin of the name for most of the rivers in the state, but there are a few whose origins remain elusive.

When I began compiling information about the various rivers of the state, I had no idea how far afield the journey would take me. There was no complete list of all the rivers in North Carolina, a void the present volume seeks to fill. Instead, I started with a simple list of rivers compiled by someone at the U.S. Geological Survey back in the 1980s. It was immediately evident that the list was incomplete, but it was a start. For nearly twenty years I have refined the list, adding several rivers until coming up with the 204 that are described in the pages of this book.

Either by canoe, kayak, boat, raft, swimming or merely hiking along its banks, I have personally visited every river mentioned in this book. Some of these journeys have involved hiking into remote terrain in search of the source of mountain rivers, or paddling the serpentine stretches of some of the swampy rivers of the eastern part of the state, which include some of the wildest territory in the southeastern United States.

# Introduction

Before beginning our discussion of the rivers of North Carolina, a note about a few river-related geographic features is in order. There are three physiographic regions or provinces located within North Carolina: the Coastal Plain, the Piedmont and the Blue Ridge. These provinces are characterized by certain features such as rock type, terrain and landforms.

The Coastal Plain Province covers the eastern third of the state from the Atlantic Ocean west to the Fall Line. Elevations range from sea level along the coast to as high as six hundred feet in the Sandhills. The topography of the region is diverse, from sandy barrier islands of the Outer Banks to rolling hills in the western part of the region.

The Piedmont Province lies in the central portion of the state between the Blue Ridge Province and the Fall Line. Several of the state's smaller mountain ranges, such as the Brushy Mountains, South Mountains and Uwharrie Mountains, are located within the Piedmont region of the state. This is the largest region of North Carolina, making up approximately 45 percent of its landmass.

The Blue Ridge Province is the name geologists give to the rugged, mountainous region of the western portion of the state covered by the Appalachian Mountains. In addition to the Blue Ridge Escarpment, it includes various other mountain ranges of the state such as the Great Smoky Mountains, the Black Mountains, the Nantahala Mountains and the Snowbird Mountains, to name a few. Mount Mitchell, with an elevation of 6,684 feet above sea level, is the highest peak in North Carolina, and is located within this province.

The Fall Line is an important geographic feature in North Carolina. This is a low ridge or cliff that parallels the Atlantic coastline running from New Jersey southwest through the Carolinas and into Georgia. It is the boundary between the resistant metamorphic rocks of the Piedmont to the west and the less resistant sedimentary rocks of the Coastal Plain. Where this boundary is crossed by rivers, it is the scene of numerous falls and rapids. Unlike cataracts such as Niagara or Victoria Falls, the waterfalls of the Fall Line are much older and have worn away at the bedrock until only the hardest rocks, normally granite, remain.

Several industries have taken advantage of the water power available along the rivers at the Fall Line. Such cities as Richmond and Washington, D.C., sprang up at the base of rapids as the rivers plunged across the Fall Line. In North Carolina, places such as Rocky Mount and Fayetteville owe their existence to the location of the Fall Line. At Rocky Mount, the Fall Line was utilized to power the Rocky Mount Mills, while

# Introduction

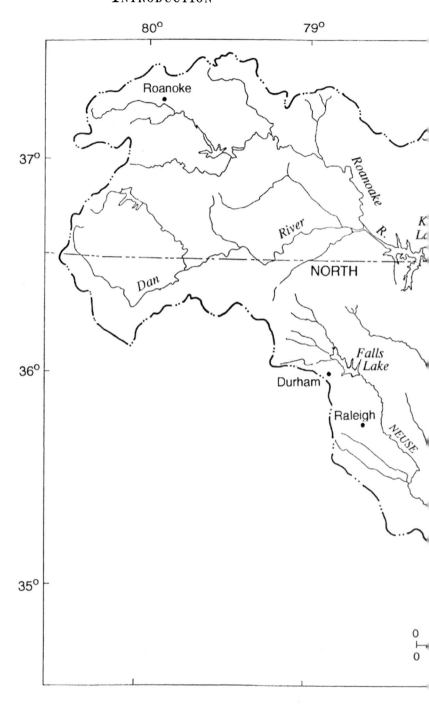

This is a map of the rivers of the Albemarle-Pamlico Basin. *Courtesy of the U.S. Geological Survey.*

# Introduction

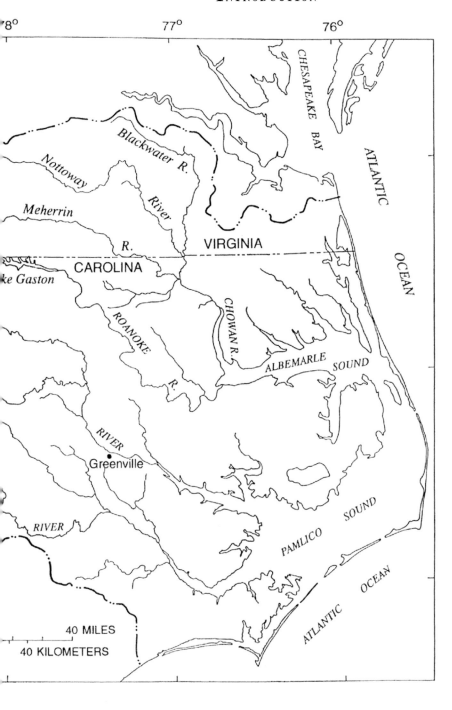

# Introduction

at Fayetteville the city's location downstream of the Fall Line led to its growth as an inland port.

A drainage basin, sometimes referred to as a watershed or a river basin, is the area that is drained and contributes runoff to a stream. For example, any creek that carries water that eventually flows into the Neuse or one of its tributaries is considered to be in the Neuse River Basin, and a creek that carries water into a tributary of the Cape Fear is considered to be in the Cape Fear River Basin. The point of land that separates respective river basins is referred to as a drainage divide.

Technically, there is no Continental Divide along the East Coast of the United States. This may come as news to many folks who have traveled the state's highways. After all, signs along several prominent roadways in the western part of the state proudly proclaim that they mark the location of the Eastern Continental Divide.

If we look at a textbook definition of a continental divide, we find that it states something to the effect that a continental divide is a line of elevated ground separating the oceanic drainage basins of a continent, and thus the river systems on the opposite side of the divide drain into two separate and distinct oceans.

In North America, there are three such divides: one separates the tributaries of the Pacific Ocean from those of the Atlantic Ocean, one separates the tributaries of the Pacific Ocean from those of the Arctic Ocean and one separates the tributaries of the Arctic Ocean from those of the Atlantic Ocean. What is commonly called the Eastern Continental Divide separates the waters that flow into the Atlantic Ocean from those that flow into the Gulf of Mexico, which is a branch of the Atlantic Ocean.

The Eastern Continental Divide is more properly a drainage divide. The various rivers on the east of the divide make their way into the Atlantic Ocean, while those on the west eventually make their way into the Mississippi River.

CHAPTER 1

# Rivers of North Carolina's Sounds

The second largest estuarine system on the East Coast of the United States, the rivers that feed into the Albemarle-Pamlico Basin drain over 36,000 square miles of land in Virginia and North Carolina. In addition to Albemarle and Pamlico Sounds, other sounds included within the system are Croatan, Bogue, Core, Roanoke and Currituck. All lie in eastern North Carolina and are separated from the Atlantic Ocean by the sandy chain of barrier islands known as the Outer Banks.

The rivers of the basin flow through a diverse territory including mountain peaks, Piedmont ridges, coastal swamps and pocosins. Rivers such as the Roanoke and Dan rise in the distant Blue Ridge Mountains. Other streams, such as the Tar and Neuse, rise in the Piedmont region of North Carolina and drain large sections of the eastern and central part of the state. Streams such as the Alligator and Pungo are coastal rivers that drain swamps and lowlands in the eastern portion of the state.

ALLIGATOR RIVER begins northwest of Fairfield and flows northeast for approximately ten miles, where it is joined by the Northwest Fork. Just south of Gum Neck, the river turns east and flows for about eight miles until it bends north at Newport News Point. The river flows by Grapevine Bay and the Frying Pan, so named because of its shape, and enters Albemarle Sound near Goat Neck and Durrant Island.

# NORTH CAROLINA RIVERS: FACTS, LEGENDS AND LORE

The Bay River in Pamlico County. This river was originally known as Bear River.

In 1984, the Alligator River National Wildlife Refuge was established to protect the valuable natural resources found in the swamps and forests along the Alligator River. Today, this vast reserve contains 152,000 acres of land in Dare and Hyde Counties, mostly swamps and pocosins on the peninsula between Croatan Sound and Alligator River. The refuge is renowned for the diversity of wildlife that can be found within its bounds, including a large population of black bear. The endangered red wolf can even be found here, thanks to a reintroduction program organized by the U.S. Fish and Wildlife Service back in the late 1980s.

The Alligator River takes its name from the American alligator, *alligator mississippiensis*, which can be spotted in some of the more remote areas of the refuge. The Albemarle Sound is considered to be the northern limit for the natural habitat of these large reptiles. Due to the longer winter season, alligators do not grow as large in the wilds of northeastern North Carolina as they do in places such as Florida and Louisiana, which have a warmer climate.

BAY RIVER begins at Stonewall, where the North Prong Bay River and South Prong Bay River unite, and flows east for about fifteen miles. The river

# Rivers of North Carolina's Sounds

The Cashie River rises in a swampy area of Bertie County before flowing into Albemarle Sound near Plymouth.

empties into Pamlico Sound past Bay River Point on the north and Maw Point on the south. The Bay River is a wide stream for most of its existence, reaching a width up to about three and a half miles in some places.

This river was originally known as Bear River, and the current name is a corruption of the earlier name. The Bear River Indians, mentioned throughout the colonial period up to the era of the Tuscarora War, lived along this river.

BLACKWATER RIVER rises near Petersburg, Virginia, and flows east then south to its junction with the Nottaway River on the North Carolina/Virginia border. These two rivers join to form the Chowan River.

The river derives its name from the color of the water, darkened by tannic acid released by rotting vegetation.

CASHIE RIVER begins near Roxobel and flows southeast through the town of Windsor. It turns northeast near Sans Souci and flows into Batchelor Bay north of Plymouth. One of its main branches connects with Roanoke

# NORTH CAROLINA RIVERS: FACTS, LEGENDS AND LORE

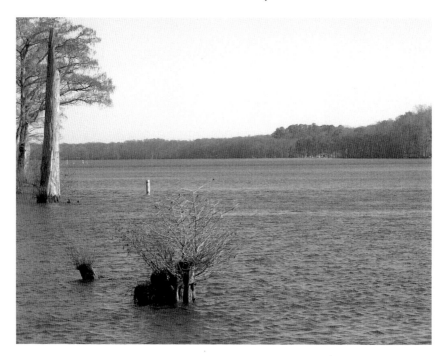

The Chowan River near Winton.

River. The Cashie drains several places with colorful names such as Roquist Pocosin, Beaver Dam Pocosin and Pell Mell Pocosin.

The origin of the river's name is uncertain. The earliest form of the name, Casiah River, shows up in land grants circa 1700. It is shown as Kesiah River on Edward Moseley's map published in 1733.

CHOWAN RIVER begins at the confluence of Blackwater River and Nottoway River at the North Carolina/Virginia border. It flows south, except for an eastward flowing stretch from Chowan Beach to Holiday Island, and enters Albemarle Sound at Edenton.

The river's name is derived from the Chowanoke Indians, who are mentioned as living in the area as early as 1586, when they formed an alliance with the colonists at Roanoke against the Tuscarora. Despite these amiable relations, the Chowanoke's affairs with the settlers coming into North Carolina deteriorated. In 1675, they waged an unsuccessful war against the colonists. This was the beginning of a period of steady decline for the tribe, who by 1755 were reported by Governor Dobbs as consisting of only two men and five women. The tribe was absorbed by their old enemies, the Tuscarora.

# RIVERS OF NORTH CAROLINA'S SOUNDS

The Dan River at Eden.

DAN RIVER rises in the mountains of Virginia near Pinnacles of Dan east of the Blue Ridge Parkway. The Dan flows south into North Carolina, passing just north of Hanging Rock, and bends north at Danbury in Stokes County. From there it flows northeast, past Reidsville and back into Virginia near Danville.

Exactly how the Dan River came by its name is a mystery. Dr. Douglas L. Rights, an authority on the history of Native Americans in North Carolina, wrote, "There are some fanciful legends that have little foundation. It seems likely that it is derived from the Siouan language."

EAST FORK ENO RIVER rises in northwest Orange County and flows south to its junction with West Fork Eno River to form Eno River. The waters of the East Fork Eno River were dammed to create Lake Orange.

EASTMOST RIVER is a branch of Roanoke River that flows along the west side of Rive Island before entering Albemarle Sound.

# NORTH CAROLINA RIVERS: FACTS, LEGENDS AND LORE

The Eno River in Durham County. This part of the river is protected as part of the Eno River State Park.

ENO RIVER begins at the confluence of East Fork Eno River and West Fork Eno River in Orange County. The Eno flows south then bends east as it flows by the historic town of Hillsborough. The river continues in an easterly direction, passing north of the city of Durham, and joins the Flat River in Durham County. The two streams combine to create the Neuse River.

The Eno River takes its name from the Eno Indians, a tribe who once lived along its banks. One tribesman, Eno Will, guided explorer John Lawson overland from Eno River to Pamlico River in 1701.

Though located in an area of intense urbanization, much of the Eno is part of Eno River State Park and thus protected from development.

FLAT RIVER begins at the junction of the North Flat and the South Flat, from which point it flows southeast across Durham County in Lake Michie. Upon leaving this lake it flows roughly two miles until it reaches the backwater of Falls Lake. In Falls Lake it unites with its popular neighbor, the Eno, to form the Neuse River.

# Rivers of North Carolina's Sounds

Hyco River begins in Person County where North Hyco Creek and South Hyco Creek unite. The river flows northeast across the state line into Virginia, where it joins the Dan River in the backwaters of Kerr Lake.

Hyco Dam was built across the Hyco in 1964 at McGeehee's Mill. This created Hyco Reservoir, a favorite haunt for fishermen and water-skiers. The dam supplies electricity for Progress Energy. The ten-mile-long reservoir is also known as Carolina Power Lake and Roxboro Lake.

In the early 1700s William Byrd called this river the "Hicotomony, or Turkey Buzzard River." The name has been shortened through the years to the modern Hyco.

Little River begins in the Great Dismal Swamp near Pasquatank and flows southeast by Nixonton before entering Albemarle Sound at Stevenson Point.

The Yeopim Indian chief Cisketando sold several hundred acres of land in what is now Perquimans County to George Durant on August 4, 1661. This was a piece of land along the peninsula jutting into Albemarle Sound separating the Little River from Perquimans River. The tract of land became known as Durant's Neck, a term still in use today. The title to this land is the earliest known deed recorded in North Carolina.

Little River (Eno) begins at the confluence of North Fork Little River and South Fork Little River in Durham County and flows southeast to the Eno River.

Little River (Neuse) rises southeast of Youngsville in Franklin County and flows south/southeast across Wake County between Zebulon and Wendell. It continues on this course across Johnston County into Wayne County and joins the Neuse at Goldsboro.

Atkinson Mill was built on the Little River in Johnston County in 1757, and has been in operation ever since. The gristmill is now on the National Register of Historic Places.

Little River (Roanoke) was once the name given to a branch of the Roanoke River that flowed around the south side of Tucker Island. The channel for this river is now covered by Roanoke Rapids Lake.

Little Alligator River rises near Newfoundland and flows in an easterly direction for approximately six miles. It enters Alligator River at Pleasant Point.

# NORTH CAROLINA RIVERS: FACTS, LEGENDS AND LORE

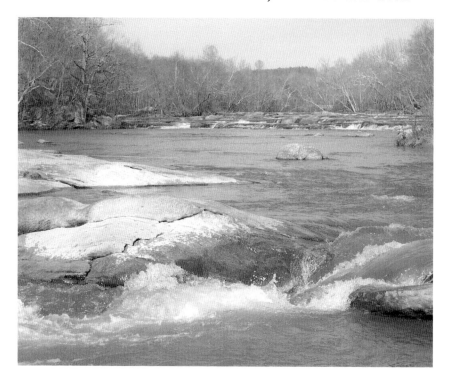

The Mayo River tumbles across this set of rapids in a remote section of Rockingham County near the Virginia border just a short distance downstream from the junction of South Mayo River and North Mayo River.

LITTLE DAN RIVER rises near Toms Knob in southwest Virginia and flows in a southerly direction across Patrick County by such peaks as Tar Kiln Mountain, Nunns Mountain and Bowens Knob. The river crosses into North Carolina and Stokes County to unite with the Dan River approximately two miles south of the border.

LONG SHOALS RIVER flows southeast out of the lowland marshes of Hyde and Dare Counties, between which counties it forms the boundary for a short distance. The river enters Pamlico Sound opposite the town of Hatteras. The shoals referred to are tidal in nature and are not related to any dramatic change in elevation, as this is a very flat part of the state.

MAYO RIVER begins at the confluence of North Mayo River and South Mayo River in Rockingham County, just south of the boundary between

## Rivers of North Carolina's Sounds

Virginia and North Carolina. It flows south by Mayodan and enters Dan River at Madison.

In the 2003 session, the North Carolina General Assembly authorized Mayo River State Park as a new unit of the state parks system. As of spring 2007, the state was still acquiring land for the new park, which will be open for visitors in the near future.

The Mayo River takes its name from Joseph Mayo, who was one of the surveyors from Virginia who laid out the boundary between that colony and North Carolina in 1728.

MEHERRIN RIVER begins at the intersection of North Meherrin River and South Meherrin River near Wightman, Virginia. It flows east by Lawrenceville and Emporia, then turns southeast and crosses into North Carolina. The river then meanders along the state line before taking a southeasterly course. After taking a pronounced bend to the west, the river meets an area of high ground and heads back toward the east at Murfreesboro, county seat of Hertford County, which is located on a high bluff on the southwestern bank of the river. The Meherrin enters the Chowan River at Parkers Ferry, about three miles upstream from Winton.

Evidence that strange creatures once swam in the waters of northeastern North Carolina have been found along the shores of the Meherrin. But unlike more famous mysterious creatures such as the Loch Ness Monster, no one has ever reported seeing these beasts sporting around in the river.

In 1969, Dr. Thomas Parramore wrote about the remains of a large creature that were discovered in the base of the hill near the old ferry crossing at Murfreesboro.

> *In the year 1816 the bones of a gigantic prehistoric shark were dug from this very cliff. The skeleton of this aquatic monster was 45 feet long, a joint of its backbone weighed twelve pounds and its sharp teeth measured six inches in length! It was carted off to Chapel Hill where for many years afterward it was used by the famed naturalist Dr. Elisha Mitchell to illustrate his lectures in Natural Science. No doubt the remains of many similar creatures still lie entombed behind the cliff walls awaiting the spade of the explorer.*

This was not the only remarkable animal to be uncovered along the shores of the Meherrin. On May 21, 1834, a man named Harlan Richard

# NORTH CAROLINA RIVERS: FACTS, LEGENDS AND LORE

The Meherrin River near Murfreesboro. The town was built on a high bluff overlooking the river.

read a paper before a gathering of the Geological Society of Pennsylvania in which he referred to an animal dug out of the base of the hill near Murfreesboro. He noted,

# Rivers of North Carolina's Sounds

*The skeleton of a huge animal was found on the bank of the Meherrin river, near Murfreesborough, N.C. It was dug out of a hill, distant sixty miles from the ocean. Capt. Neville, and Dr. Fowler, who visited the spot, gathered the scattered vertebrae which the negroes had thrown out, and laid them in a row thirty-six feet in length. If to this the head and tail be added, the animal must have been fifty feet or more in length. The former of these gentlemen enriched my collection with two of the teeth and a joint of the neck bone: the teeth weigh sixteen ounces each; they are covered with an ash-colored enamel, except at the roots where they are fastened to the jaws; the sides of the triangles are six inches long, and the base is four inches and a half across. The single vertebra weighed twelve pounds and a half. These fossils are at present in the cabinet of the Lyceum of Natural History in New York. We have recognized them as the remains of a gigantic species of shark.*

To this day, fossil hunters continue to probe the shores of the Meherrin, searching for the elusive remains of these mysterious creatures that lived and swam in the waters of our state so many millions of years ago.

The river takes its name from the Meherrin Indians, who lived along the river in Virginia when the first settlers arrived. By the early 1700s the tribe moved downstream and settled in the remote area near the mouth of the river in North Carolina. On April 2, 1728, the commissioners running the boundary line between North Carolina and Virginia were camping near the mouth of Nottoway River, where they were visited by a group of Meherrin Indians. Colonel William Byrd, one of the commissioners, wrote a note about the visit in his journal.

*In this camp three of the Meherrin Indians made us a visit. They told us that the small remains of their nation had deserted their ancient town, situated near the mouth of the Meherrin river, for fear of the Catawbas, who had killed fourteen of their people the year before; and the few that survived that calamity, had taken refuge amongst the English, on the east side of Chowan. Though, if the complaint of these Indians were true, they are hardly used by our Carolina friends. But they are the less to be pitied, because they have ever been reputed the most false and treacherous to the English of all the Indians in the neighbourhood.*

Descendants of the Meherrin still live in the vicinity of the Meherrin River today. The name is from the Meherrin's original language and means "people of the muddy water."

# NORTH CAROLINA RIVERS: FACTS, LEGENDS AND LORE

Parker's Ferry carries cars across the Meherrin River in a remote section of Hertford County.

MIDDLE RIVER is actually a branch of the Roanoke that splits away east of Plymouth. It flows northeast for about five miles until it enters Batchelors Bay.

MOCCASIN RIVER begins at the confluence of Contentnea Creek and Little Contentnea Creek in Lenoir County and flows southeast along the Lenoir/Pitt County line to the Neuse. This is an old and seldom-used term for this watercourse; most modern maps refer to it simply as a continuation of Contentnea Creek.

Bill Sharpe, in his *New Geography of North Carolina* series written in the late 1950s, noted how the Moccasin derived its name. "When Congress was petitioned to appropriate funds to clear the channel of Contentnea Creek, which flows into the Neuse, it was replied that policy permitted waterway work on rivers, not creeks. Whereupon Pitt renamed Contentnea Creek, put it on record as 'Moccasin River,' and obtained the funds. The 'river' long since disappeared from maps."

# Rivers of North Carolina's Sounds

NEUSE RIVER begins at the confluence of Eno River and Flat River in the backwaters of Falls Lake between Butner and Durham. From this spot, it is nearly 262 miles to the mouth of the river at Pamlico Sound. Falls Lake stretches nearly 28 miles upriver from Falls Dam. According to the U.S. Army Corps of Engineers, the lake covers over 11,000 acres and has approximately 175 miles of shoreline. The dam stretches 1,915 feet across the river, and stands 92.5 feet tall.

From Falls Lake the Neuse travels by Raleigh and veers southeast near Walnut Creek. Near Wilson's Mills the Neuse turns southwest past Smithfield, the county seat of Johnston County.

The Neuse meanders southeast as it makes its way past Goldsboro. Old Waynesboro, once a thriving river port town and county seat of Wayne County, was located on the north bank of the river. The town prospered during the days of river transport, but fell upon hard times after the railroad passed it by and a new town called Goldsboro came into existence nearby. Today, the site is a historic village and museum.

Beyond Goldsboro, the Neuse flows by Seymore Johnston Air Force Base as it continues east. Between Goldsboro and Kinston, the river passes a high bluff known as Cliffs of the Neuse. This picturesque site is the home of Cliffs of the Neuse State Park. Atop the bluff is an overlook and a small museum.

Downstream from the Cliffs of the Neuse, the river passes Seven Springs, a place steeped in history dating back to before European settlement of the area. People were drawn to this spot because of the springs, each of which was reputed to cure a specific ailment. Water from springs 1 and 2 were good for the kidneys, number 3 was good for the liver and number 4 was good for the stomach. Springs 5 and 6 were beneficial to those suffering from too much acid in their body. Finally, spring number 7 was believed to be good for those suffering from high blood pressure.

The town here was originally known as White Hall, and dated back to before the American Revolution. The town prospered as riverboats and stages brought visitors to the springs in the first half of the nineteenth century. But during the War Between the States, the town was destroyed during a battle fought here on December 15, 1862. When the war ended, prosperity was slow in returning to the area. A new town, renamed Seven Springs, grew up on the site of White Hall, and visits to the springs resumed. Two hotels flourished here, including the famed Seven Springs Hotel.

One interesting bit of Civil War history connected with Seven Springs is the fact that it was the site where the Confederates began construction of an ironclad vessel christened the CSS *Neuse*. An informational display

# NORTH CAROLINA RIVERS: FACTS, LEGENDS AND LORE

The view from atop the high bluff at Cliffs of the Neuse State Park.

near the boat ramp on the south side of the river gives an account of how the Southerners used this out-of-the-way locale as a place in which to construct their vessel. Remains of the ironclad can still be seen downstream in Kinston at the CSS *Neuse* State Historic Site.

The Neuse widens considerably as it reaches New Bern, a city intricately tied to the river. Located at a strategic junction of the Trent and Neuse Rivers, the city was founded in 1710 by Swiss colonists. The city has had an eventful history, including being the scene of fierce fighting during the War Between the States. But the city is perhaps best known as the place where Pepsi-Cola was invented back in 1898 by a pharmacist named Caleb Bradham.

After passing the mouth of Trent River, the Neuse continues in an easterly direction, flowing past Minnesott Beach, where the river takes a northeast turn. Legend states that a horde of gold from the banks in New Bern was buried somewhere along this stretch of river during the onset of the War Between the States. Those who were present when the gold was buried were killed during the war, and took the knowledge of the gold's location to the grave with them. The treasure has never been discovered.

Oriental, at the mouth of the river, was named for a ship that wrecked on the Outer Banks in 1862. The town is renowned as one of the premier sailing destinations along the East Coast of the United States.

# RIVERS OF NORTH CAROLINA'S SOUNDS

The Neuse River between Kinston and New Bern.

The river enters Pamlico Sound between Maw Point and Point of Marsh. According to the U.S. Geological Survey, the Neuse River has the largest mouth of any river in the country.

The Neuse River drains over 5,700 square miles of land located in the central and eastern part of the state. The upper reaches of the basin are located in some of the most urbanized areas of North Carolina, with tributaries such as Crabtree Creek and Walnut Creek flowing through the heart of Raleigh. Other water-quality pressures have also been put on the waters of the Neuse because the large-scale livestock production poses a threat to water quality in the downstream portions of the basin.

Arthur Barlowe, one of the explorers sent out on a reconnaissance mission to the New World by Sir Walter Raleigh in 1584, is credited with naming the Neuse. He named it for the Neusiok Indians, who lived along the lower reaches of the river.

Dr. Douglas L. Rights estimated that there were some one thousand Neusiok and Coree Indians living at the time of first contact with the English. By 1701, the Neusiok had been reduced by war and pestilence to the point where they were only able to muster fifteen fighting men.

Close allies of the Tuscaroras, those who were left of the Neusiok sided with them during the Tuscarora War. Shortly after the defeat of

# NORTH CAROLINA RIVERS: FACTS, LEGENDS AND LORE

The Newport River at Morehead City.

the Indians, the Neusiok disappeared from the pages of history. Whether they were wiped out during the war, absorbed into the Tuscarora or were merely assimilated into the European colony is unknown.

NEW LAKE FORK OF THE ALLIGATOR RIVER flows out of Alligator Lake and flows southeast about five miles before entering Alligator River.

NEWPORT RIVER begins in the Croatan National Forest west of the town of Newport and flows east for about eight miles through Carteret County before it widens to about a mile in width. It makes a sweeping bend to the south and flows into Bogue Sound between Morehead City and Beaufort.

The Newport is the home of North Carolina's second largest seaport, second only to the Cape Fear at Wilmington.

The river was originally known as the Coranine River.

NORTH FLAT RIVER rises near the Person County community of Paynes Tavern south of Roxboro. It flows southeast to its union with South Flat, and it is this point that is the beginning of the Flat River.

There is an interesting legend concerning the community of Paynes Tavern. Local folks believe this to be the true birthplace of Dolley Payne

# Rivers of North Carolina's Sounds

Madison, wife of President James Madison. The legend states that she was born in Payne's Tavern while her parents were visiting the family, who were kinsmen of Dolley's father.

NORTH FORK LITTLE RIVER rises in northern Orange County and flows east into Durham County, where it unites with the South Fork Little River near Quail Roost to form Little River (Eno).

NORTH FORK TAR RIVER rises northeast of Oxford and flows west then south to join the Tar River in Granville County.

NORTH LANDING RIVER rises between Norfolk and Virginia Beach, Virginia, and flows south/southeast into North Carolina. It enters Currituck Sound near Knotts Island. The headwaters of the North Landing River and the Eastern Branch of Elizabeth River (which flows north into Chesapeake Bay) originate from the same source near Kempsville.

The Intracoastal Waterway utilizes the North Landing River in connecting Currituck Sound and Chesapeake Bay. A canal from North Landing River to the southern branch of Elizabeth River provides the connection.

NORTH MAYO RIVER begins at the junction of Spencer Creek and Polebridge Creek in Patrick County, Virginia, and flows southeast into Henry County and turns south to cross into North Carolina. It then unites with South Mayo River less than a mile below the state line to form the Mayo River.

NORTH PRONG BAY RIVER rises on the north side of the town of Bayboro and flows east to unite with the South Prong to form Bay River at Stonewall. The town of Stonewall was named in honor of Confederate General Thomas J. "Stonewall" Jackson, whose brilliant military career was cut short at Chancellorsville, Virginia, in 1863.

NORTH RIVER begins in Great Swamp where Indiantown Creek and Bull Frog Creek unite. It flows south into Albemarle Sound at Camden Point, forming the boundary between Camden and Currituck Counties. The North River is connected with the North Landing River via the Intracoastal Waterway and Coinjock Bay.

NORTH RIVER begins in central Carteret County about eight miles north of Beaufort (see also South River of the Neuse system). It flows south and

# NORTH CAROLINA RIVERS: FACTS, LEGENDS AND LORE

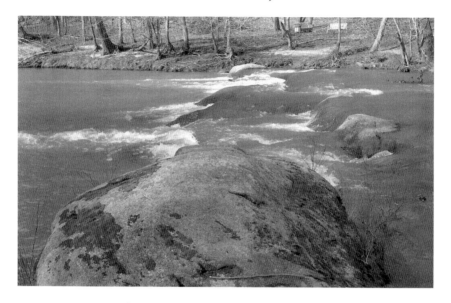

The North Mayo River near the Virginia border.

enters Back Sound to the south, and flows through the Straits into Core Sound on the east.

The landmass that divides the mouth of this river is Harker's Island, a popular port for recreational fishermen and ferry terminal for travel to Cape Lookout. The island derives its name from a family who obtained the island in the early 1700s. Prior to this, it was known as Craney Island.

NORTHWEST FORK OF ALLIGATOR RIVER rises in Hollow Ground Swamp northwest of Gum Neck. The river flows southeast and joins the Alligator River west of Cherry Ridge Landing. The Northwest Fork of Alligator River is connected with the Scuppernong River to the north via canal.

NORTHWEST PRONG NEWPORT RIVER rises in the Lakes Pocosin in Croatan National Forest in Carteret County. It flows south/southeast to its junction with the Southwest Prong Newport River near Holly Springs.

NORTHWEST RIVER rises in the Dismal Swamp in southeastern Virginia and flows southeast to its junction with Smith Creek, where the river widens considerably, bends south and crosses into North Carolina. It flows east/southeast into the North Landing River near Tull Bay.

# Rivers of North Carolina's Sounds

Nottoway River begins on the border of Prince Edward and Lunenburg Counties in Virginia. It flows in an easterly direction before turning southeast between Petersburg and Emporia. At the North Carolina/Virginia border, the Nottoway and Blackwater Rivers flow together to form Chowan River.

The Nottoway takes its name from the Nottaway Indians, who once lived along its banks.

Pamlico River begins in Beaufort County where Tranters Creek joins Tar River. Here the Tar widens considerably and takes the name Pamlico River. The Pamlico flows southeast by the town of Washington, and doubles in width when it passes Fork Point. The river continues east/southeast until it enters Pamlico Sound at Pamlico Point. The river is approximately thirty-five miles long.

On the north side of Pamlico River, just a short distance up Bath Creek, stands the historic town of Bath. Established in 1705, this town has the distinction of being the first town officially created in the colony of North Carolina. The site was chosen because of its sheltered location on Pamlico River, which served as an important transportation route for goods passing between the interior of the growing colony and the inlets through the Outer Banks.

The first two decades of the seventeenth century were eventful years for the history of the town. A brief but fierce fight known as Cary's Rebellion raged between rival factions of the government in 1711. The following year a war broke out with the Tuscarora Indians that nearly led to the destruction of the entire colony. But the most memorable event of the town's history came when the pirate Edward Teach, alias Blackbeard, took up residence in the town in 1718.

Blackbeard's house was reputed to have been on the east side of Bath Creek on the point of land known as Teach's Point, which is today called Plum Point. Many believe that the famous pirate buried his treasure somewhere in the vicinity of his house. Whether this is true or not is open to speculation, but for nearly three centuries treasure hunters have tried to find the hidden booty.

There were rumors that Blackbeard was working clandestinely with Governor Charles Eden and colonial Secretary Tobais Knight to make money off of stolen goods. Both of these men lived in Bath and were seen in company with Teach on several occasions. It was even said that Eden performed the wedding ceremony for the pirate and his fourteenth bride.

# NORTH CAROLINA RIVERS: FACTS, LEGENDS AND LORE

The North River flows by Harker's Island in Carteret County.

If Blackbeard did all that has been attributed to him after his arrival at Bath, he was indeed a busy man. In the five months between June, when he arrived in town and took the royal pardon from the governor forgiving all past misdeeds of a piratical nature, and November, when he was killed

in the battle off Ocracoke, he is known to have sallied forth on the high seas in search of plunder, as well as laid the groundwork for a pirate base on Ocracoke. This would have left very little time for building houses, burying treasure and marrying at least two women—one in Beaufort and one in Bath.

# NORTH CAROLINA RIVERS: FACTS, LEGENDS AND LORE

A ferry crosses the Pamlico River near Aurora.

Bath prospered for more than half a century, but its fortunes declined as more convenient ports developed along the colony's rivers and inland waterways. However, some attribute the decline to a curse put on the town by the Reverend George Whitefield, who was not very hospitably received on his visit to the town. After preaching to the townspeople, who took little heed of his warnings of the fate awaiting sinners, he decided to leave the place for a more receptive audience. According to legend, as the reverend was leaving town, he climbed up on the back of his wagon and told those within earshot, "There's a place in the Bible that says if a place won't listen to The Word, you shake the dust of the town off your feet, and the town shall be cursed. I have put a curse on this town for a hundred years." True to the reverend's words, the town stopped growing, and eventually became little more than a fishing village by the turn of the eighteenth century.

The town of Bath lost its commercial appeal after another town was established farther up the Pamlico River. In the early 1770s, James Bonner established a town that he called "Forks of the Tar." In 1776, after his service in the Continental army in the early years of the Revolutionary War, Bonner renamed his town Washington, in honor of General George Washington. The Washington on the Tar may not be as large or as famous

as the Washington on the Potomac, but it has the distinction of being the first town named for George Washington in the entire United States.

Though now only used to designate the estuarial portion of this river, the name Pamlico was the original name given to the entire length of Tar River. The name is derived from the Pamlico Indians who once lived along the river.

PASQUOTANK RIVER begins in the Dismal Swamp, where numerous streams and swamps flow together to form a narrow river. This river flows southeast until it makes a sharp curve to the west at Elizabeth City before heading back southeast until it reaches a point known as the Narrows. From here the Pasquotank becomes a large, wide watercourse to its mouth on Albemarle Sound.

The Pasquotank gets its name from an Indian word, Pashetanki, which means "where the river forks."

Kiscutanaweh, chief of the Yeopim Indians, deeded a tract of land in the year 1660 to Captain Nathaniel Batts that included the land "on ye southeast side of Pasquatank River from the mouth of ye said river to ye head of New Begin Creeke." Though it was filed in Virginia, this is the earliest surviving deed recorded for land in what is now North Carolina.

In the year 1666, a group of colonists from Bermuda settled along the Pasquotank. Their settlement grew and in 1672 Pasquotank Precinct became an entity within old Albemarle County. The precinct continued to grow, gaining a customs house and other official buildings at the Narrows, so in 1739 Pasquotank County was established as a full-fledged county.

In 1791 Elizabeth City (originally called Reading) was officially founded at the Narrows. It has grown ever since and today is the largest city in northeastern North Carolina. Legend states it was named for Elizabeth Tooley, a popular tavern keeper who lived nearby.

PERQUIMANS RIVER rises in the northern part of the county with the same name. It meanders southwest to Hickory Crossroads, south to Belvidere, then southeast by Hertford to Albemarle Sound. Below Hertford the river widens considerably, being in some places more than a mile wide.

The Perquimans takes its name from a Yeopim Indian phrase meaning "island of the beautiful women." The exact location of this island is currently unknown.

PUNGO RIVER rises near Wenona in the East Dismal Swamp and flows southeast to Leechville, where it widens and bends west to Belhaven.

# NORTH CAROLINA RIVERS: FACTS, LEGENDS AND LORE

The Pungo River in Beaufort County.

From there the Pungo heads southeast again until it empties into the Pamlico River near Pamlico Beach.

The Pungo is connected with Pungo Lake via numerous canals. The lake covers almost three thousand acres, but only reaches a depth of five feet. It lies within the Pocosin Lakes National Wildlife Refuge.

The name Pungo is derived from a tribe of Indians known as the Machapunga, who once inhabited the area.

ROANOKE RIVER drains 9,580 square miles of land in Virginia and North Carolina. The river travels over 400 miles in its journey from the mountains to Albemarle Sound. The Roanoke begins at the junction of North Fork Roanoke River and South Fork Roanoke River near Lafayette, Virginia, on the western side of the Blue Ridge. The river flows northeast approximately 10 miles to Salem, then continues in an easterly direction through Roanoke. It then turns southeast and cuts across the Blue Ridge onto the Piedmont. The river flows in a southeasterly direction across the Piedmont region of Virginia and enters North Carolina.

The Roanoke is impounded three times as it crosses Virginia between the mountains and the Coastal Plain. The first is Smith Mountain Lake, the second at Leesville Lake. The third dam in Virginia, John H. Kerr Dam, is located in the extreme southern part of the state, and impounds

the river to create the Kerr Lake. This dam was named in honor of Congressman John H. Kerr, a native of Warrenton, North Carolina.

There are two dams across the Roanoke River in North Carolina. Gaston Dam stands 105 feet high and stretches 3,600 feet across the river just downstream from the Virginia border. The resulting reservoir, Lake Gaston, has a surface area of 20,300 acres, and backs the river upstream 34 miles into Virginia to the foot of the John H. Kerr Dam. Gaston Dam was built by Virginia Electric and Power Company in 1963. The next dam, Roanoke Rapids Dam, is located approximately 8 miles downstream. Completed in 1955, the resulting lake has a surface area of 4,900 acres. The river flows unimpeded from Roanoke Rapids to Albemarle Sound, a distance of nearly 130 miles.

In 1889, Captain William Bixby of the U.S. Army Corps of Engineers examined the Roanoke from Clarksville, Virginia, to Eaton's Ferry, North Carolina. His observations of this part of the river preserve a valuable description of this section before the large reservoirs were constructed. He noted,

> *From Clarksville, the Roanoke flows in a general south by easterly direction through Mecklenburg County, Va., Warren County, N.C., and thence between Northhampton and Bertie counties on the north and Halifax and Martin counties on the south, a distance of 56 miles by river (47 miles by air line), to Eaton's Falls; thence 13 miles by river (11 miles by air line) to Weldon; and thence 129 miles by river (60 miles by air line) to its mouth in Albemarle Sound. From Clarksville to Eaton's Falls the river falls 146 feet (2.6 feet per mile); from Eaton's Falls to Weldon, 104 feet (8 feet per mile); but below Weldon it is so gentle a slope (about 0.3 feet per mile) and so good a channel that it is there easily navigable by steamers of 3 feet draught all the year, and of 5 feet draught during the greater part of the year. From Clarksville to Eaton's Falls the river flows most of the way over a granite rock bed, and between banks of from 12 to 120 feet height, having a general depth of 2½ feet at low water (varying from 1 to 10 feet at places) and a width of from 500 to 1,300 feet; the river valley bottom having a width of from 1,000 to 15,000 feet.*

Once the river reaches Roanoke Rapids, it begins its descent across the Fall Line. Over the next nine miles, the river flows through a section of rocks and rapids as it descends eighty-five feet, creating what was once

# NORTH CAROLINA RIVERS: FACTS, LEGENDS AND LORE

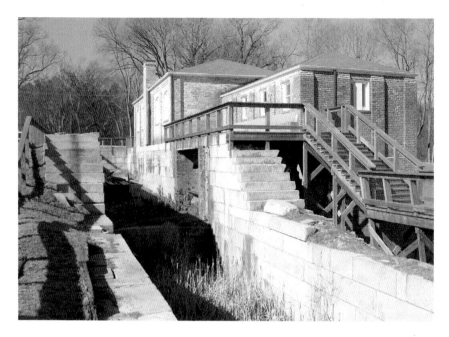

The Roanoke Canal Museum in Weldon is located inside this building, which used to be the powerhouse built by the Roanoke Navigation and Water Power Company.

referred to as the Great Falls. Today the upper portion of the Great Falls of the Roanoke are under the backwaters of Roanoke Rapids Lake. However, the rapids downstream of the dam are still present in the river, culminating in the set of rapids called Weldon Falls.

In July of 1816, W.J. Lewis published a letter in *Niles' Weekly Register* advocating the improvement of the Roanoke for navigation, providing an outlet for a vast area of North Carolina and Virginia with the sea via Norfolk. Of the Great Falls he wrote, "The principle obstacle to the navigation of this river is the Great falls in the state of North Carolina. They are twelve miles from head to foot, and in that distance descend 100 feet, which is eight feet, four inches to the mile. On the south side of the river the distance by land would be eight miles, with a descent of twelve feet six inches per mile."

Between 1817 and 1823, the Roanoke Navigation Company built a canal to bypass the Great Falls. Once completed, the Roanoke Canal stretched nine miles along the southern bank of the Roanoke, utilizing locks, dams and aqueducts to traverse the rugged terrain. Though no longer in use, the remains of these works are now the focal point of a river trail that follows the canal from Roanoke Rapids Lake to Weldon.

# Rivers of North Carolina's Sounds

The Roanoke Canal Museum, which occupies one of the powerhouses built alongside one of the lock structures, gives visitors an opportunity to learn in depth about the effort to tame the Roanoke. A replica of one of the bateaux that plied the river in the early 1800s loaded with cargo rests outside the museum within the walls of the lock.

Approximately ten miles downstream from Weldon, the river passes the historic town of Halifax, once an important trading town that was founded in 1760. It is strategically located along the southwestern bank of the Roanoke River downstream from the major rapids. During the American Revolution, the Provincial congress met several times in Halifax, and on April 12, 1776, proclaimed their independence from Great Britain with the adoption of the Halifax Resolves. The town prospered for more than half a century after the war, but when the Wilmington and Weldon Railroad passed just west of town, Halifax started a period of steady decline. Today the site is preserved as part of the Historic Halifax State Historic Site.

In 1989, the Roanoke River National Wildlife Refuge was established along the river to protect the valuable natural resources of the swamps and bottomlands along the lower reaches of the Roanoke. The refuge contains over 17,500 acres of land distributed in several tracts of various sizes from Hamilton downstream to the mouth of the river. The forests of the refuge are divided between 9,500 acres of bottomland hardwood forest and 8,000 acres of cypress/tupelo swamp.

Thanks to the annual spring migration of the striped bass up the Roanoke River, Weldon is known as the "Rockfish Capital of the World." The migration begins in the spring as the rockfish begin moving upstream from Albemarle Sound to their spawning grounds in the rapids. The fish slowly progress up the river, and by the beginning of April many have made their way into the upper reaches of the river in the vicinity of the rapids at Weldon. Some biologists postulate that even if the dam was not standing at the head of the rapids, it is doubtful that the fish would proceed any farther upstream.

Historically, fishing for rockfish in the rapids on the Roanoke was an important aspect of life for those who lived near the river. The rural folk maintained the tradition started by the Native Americans of visiting the rapids during the spring to catch fish to supplement their diet. Many utilized bow nets and weirs to catch large numbers of striped bass. Unfortunately, as the human population increased and fishing methods became more lethal, the fish stocks were nearly depleted.

# NORTH CAROLINA RIVERS: FACTS, LEGENDS AND LORE

The current sports fishery for rockfish is a testimony to the success of conservation efforts. Overfishing in the Roanoke River nearly destroyed the striped bass population, and in the 1980s it was necessary to restrict the harvest of these fish. The population has since rebounded, and a thriving sports fishing industry has ensued, with anglers coming from all over the country to try their luck landing one of these big fish. During April and May, the river is full of stripers, and there are reports of some anglers landing as many as one hundred in a single day.

At its meeting on June 11, 1959, the U.S. Board of Geographic Names officially decreed that the river would be known by two separate names. Their official report states, "It is often locally called Staunton River in the section extending upstream from the reservoir impounded by the John H. Kerr Dam to about the Back Creek where the Bedford, Franklin and Roanoke boundaries join; for this section of the stream the name Staunton River may be used parenthetically after decision name if desired." Exactly where the name Staunton came from is uncertain. Some suggest that William Byrd and the boundary commissioners laying out the North Carolina and Virginia border in 1728 may have named it in honor of Rebecca Staunton Gooch, wife of then–Virginia Governor Sir William Gooch.

The name may predate 1728. Between March of 1669 and September of 1670, Dr. John Lederer made three trips into the wilds of the backcountry of Virginia and North Carolina. In an account of his travels published in 1672, he included a map that shows, among other things, Roanoke River. Lederer labeled the river "Rorenock alias Shanan." This is not too far removed from the modern rendering of the name for the "Roanoke alias Staunton River."

The river was not originally known as the Roanoke, though that name has been in use for at least part of the river for nearly four hundred years. To the Native Americans it was the Moratock, which meant "river of death." Why they chose such an ominous name for the river is unknown, but the name or derivations thereof remained in use well after the first settlers began arriving in the region in the seventeenth century. On the Comberford Map published in 1657 the river is labeled "Morattico River."

In August of 1650, Edward Bland of Virginia set out on an exploring expedition that took him to the Roanoke. He referred to the river as the "Hocomawananck." His attempt to change the name from this difficult word into something a little easier to pronounce—Blandina River—failed.

SCUPPERNONG RIVER rises near Cherry in Washington County, from where it meanders east until it turns northwest near Columbia and

# RIVERS OF NORTH CAROLINA'S SOUNDS

The Roanoke River flows through an area of swampy lowlands near Hamilton.

empties into the Albemarle Sound near River Neck. Some of the waters of Phelps Lake empty into tributaries of the Scuppernong.

The Scuppernong River is one of the state's most remote rivers. There are few signs of construction along the river upstream from Columbia, and much of the floodplain and surrounding land has been protected by various government agencies.

Scuppernong grapes, a variety of muscadine grape, were named for this river. This variety of grape, the first native wine grape to be cultivated in the Americas, was once the mainstay of North Carolina's wine industry. The grape is still widely popular throughout the Southeast.

The river takes its name from an Indian word, askuponong, which means "place of the bay trees," referring to the vegetation surrounding the lake. Edward Moseley's *A New and Correct Map of the Province of North Carolina*, published in 1733, labeled the stream "Cascoponung River."

SMITH RIVER begins in Patrick County, Virginia, at the confluence of North Fork Smith River and South Fork Smith River. It flows northeast to the Patrick/Franklin County line, then flows southeast through Philpott Lake, enters Henry County and flows by Bassville, Collinsville and Martinsville. The river then enters North Carolina north of Eden and joins the Dan River north of town.

# NORTH CAROLINA RIVERS: FACTS, LEGENDS AND LORE

The Smith River in Rockingham County near Eden.

This river was originally called the Irvine River, in honor of a professor at the College of William and Mary, Alexander Irvine. His name was attached to this watercourse as he was one of the surveyors who laid out the boundary separating North Carolina and Virginia in 1728. By the turn of the nineteenth century, that name was dropped and Smith River was being used. The identity of the person named Smith for whom the river is named is currently unknown.

SOUTH FLAT RIVER rises in Person County near the town of Gordonton and flows east to its junction with the North Flat River near Timberlake.

SOUTH FORK LITTLE RIVER rises in northern Orange County less than three miles from the headwaters of the North Fork Little River and less than five miles from the head of the Eno. It flows southeast to unite with North Fork Little River in Durham County where Little River (Eno) begins.

SOUTH MAYO RIVER rises on Rock Mountain near Stuart, Virginia, and flows southeast across Patrick County to Henry County. It enters North Carolina near Stoneville in Rockingham County, where it joins North

# Rivers of North Carolina's Sounds

The South Mayo River upstream from its junction with the North Mayo River.

South River in Carteret County.

# NORTH CAROLINA RIVERS: FACTS, LEGENDS AND LORE

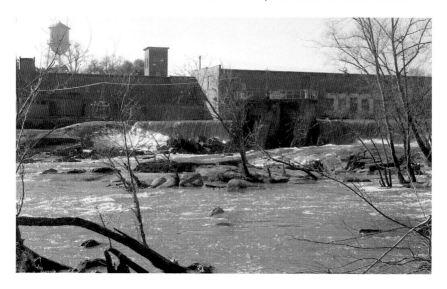

The Great Falls of the Tar at Rocky Mount.

Mayo River to form Mayo River.

SOUTH PRONG BAY RIVER begins on the south side of the town of Bayboro in Pamlico County. It flows east to unite with the North Prong Bay River at Stonewall where the Bay River begins.

SOUTH RIVER rises in eastern Carteret County and flows northwest to join the Neuse at Horton Bay.

SOUTHWEST FORK ALLIGATOR RIVER drains Alligator Lake via canal from the lake's northeast corner. The river flows about eight miles before it enters the Northwest Fork of Alligator River.

SOUTHWEST PRONG NEWPORT RIVER rises in the southern part of Lake Pocosin and flows east to its confluence near Holly Springs with the Northwest Prong Newport River, where Newport River begins.

TAR RIVER rises in eastern Person County and flows south before turning southeast near Peeds Store. The river flows more or less southeast as it flows out of Granville County and by Louisburg. It turns northeast in Nash County to Rocky Mount, then east to Tarboro, where the river bends south. The river makes a gradual bend to the

east as it passes Greenville and becomes Pamlico River after it is joined by Tranters Creek.

The large dam spanning the Tar River at Rocky Mount was built to harness the power of the Great Falls. In 1816, Joel Battle, Peter Evans and Henry Donaldson built a cotton mill here, which has the distinction of being the second cotton mill erected in North Carolina. Union troops burned the first mill in July of 1863, and fire destroyed its replacement in 1869. The current structure was built circa 1870.

When Rocky Mount Mills closed in 1996, it was reputed to be the oldest cotton mill still in operation in the South. The mill structure and dam still stand.

In 1816, Benjamin Baldwin examined the Tar River, looking at the feasibility of opening the river to navigation. He made several interesting observations about the river in the vicinity of the Great Falls.

> *If the utility of the navigation above the falls should be thought of sufficient importance to justify the expense of improving it, the first obstacle to be surmounted is at Andrews' Mills. The falls here are short and have a descent of nine feet...From this place to the Great Falls, a distance of two miles, the river is gentle. From the first of these falls to the dams built by the proprietors of the mills on each side of the river, the distance of which varies from fifteen to thirty rods, and the river's having a rocky bed, there is a fall of twelve feet. These dams pond the water back to the foot of Goodson's falls, a distance of four hundred yards or thereabouts. Those falls consist of rapids over a rocky bed of the river, having a descent of four feet in a distance of seventy or eighty rods.*

Even though a dam was built at the head of the falls to harness the energy, the site of the Great Falls of the Tar is still an impressive scene. After the water flows over the dam, the Tar plunges through a set of rapids as it races past large boulders. At the end of the falls, the river divides and flows around Panther Island. The land on the south side of the river, complete with an overlook of the falls from atop a rocky bluff, is part of the city of Rocky Mount's Battle Park.

The Tar River Basin, which covers 5,400 square miles, contains all or part of the following counties: Beaufort, Dare, Edgecombe, Franklin, Halifax, Hyde, Martin, Nash, Pamlico, Person, Pitt, Vance, Warren, Washington and Wilson. All of the watercourses drain into Pamlico Sound.

# NORTH CAROLINA RIVERS: FACTS, LEGENDS AND LORE

There is much debate as to how and when the Tar got its name. Some claim it derives from an Indian word. Others claim that it was named by early settlers for a river in England. One thing is certain, however. The legend that Tar River received its name from Cornwallis's troops when they crossed it in the spring of 1781 is not true. The name predates this event by at least fifty years, for it is mentioned in 1728 in the field book of the North Carolinians surveying the boundary line with Virginia.

Less than twenty years before the surveyors recorded the name Tar, the renowned explorer and author John Lawson labeled it as "Pampticough River" on a map he drew in 1709.

In 1811, Jeremiah Battle presented an account of the natural resources and history of Edgecombe County to the local agricultural society. He noted that the name Tar was given to the river by the local Indians, who viewed it as a healthy place.

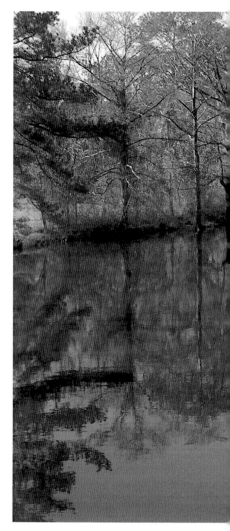

> *It appears that Roanoke was considered, even by the natives, who lived in the woods, as a sickly place. Those who changed their residence from that river to this, called this Tar river, signifying, it is said, the river of health. It rises in Granville county, and runs through Franklin, Nash, Edgecombe, Pitt and Beaufort counties, and empties into Pamtico [sic] sound. It is navigable a considerable part of the year for boats of a particular construction, carrying from 200 to 400 barrels as high up as 15 miles above Tarboro, in a straight direction, which is 40 or 50 by water.*

The Trent River at Pollocksville.

## RIVERS OF NORTH CAROLINA'S SOUNDS

TRENT RIVER rises near the Lenoir/Duplin line north of Pink Hill and flows southeast out of Lenoir County, then meanders in an easterly direction through Jones County. It widens considerably after entering Craven County and joins the Neuse at New Bern.

The river was once navigated by steamboats as far up as Trenton. The U.S. Army Corps of Engineers mapped the thirty-eight-mile stretch from there to New Bern back in 1888.

The Trent is thought to derive its name from the Trent River in England.

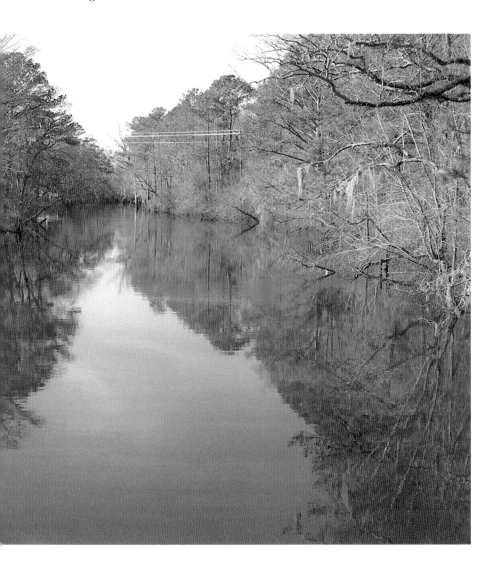

# NORTH CAROLINA RIVERS: FACTS, LEGENDS AND LORE

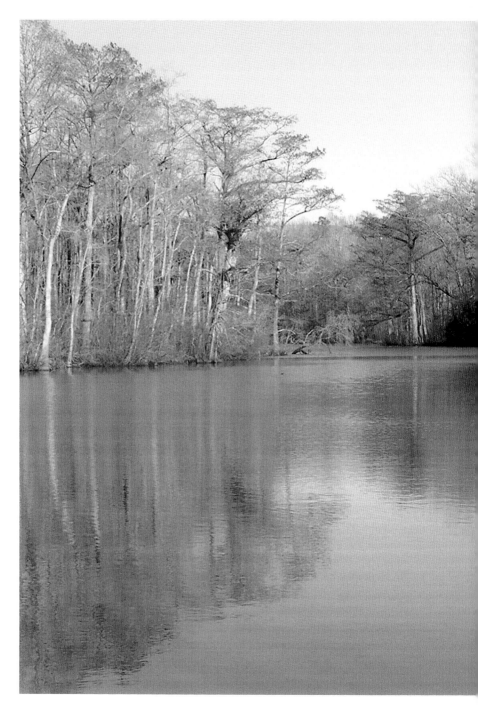

The Wiccacon River near Harrellsville in Hertford County.

# Rivers of North Carolina's Sounds

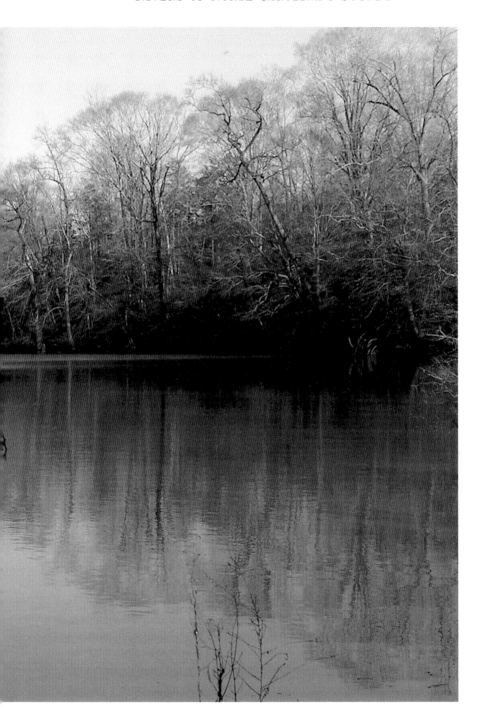

# NORTH CAROLINA RIVERS: FACTS, LEGENDS AND LORE

WEST FORK ENO RIVER rises in northwest Orange County and flows south to its junction with the East Fork Eno River.

WEST FORK SOUTH RIVER rises in eastern Carteret County and flows northeast approximately three miles to its confluence with the South River.

WICCACON RIVER begins in Hoggard Swamp east of Ahoskie and meanders east to the Chowan River. According to local historian F. Roy Johnson, the name is of Indian origin. "In the Wyonoke language it meant 'little river' or 'little creek.' The Iroquoian Nottaways called it Quaur-aur-aur-augh."

YEOPIM RIVER rises in Bear Swamp north of Edenton and flows southeast to Albemarle Sound at Snug Harbor. The river is named in honor of the Yeopim Indians, who once resided along its banks.

At the mouth of Yeopim River is a set of shoals where stood Batts Island. The island was once a prominent landmark in the area, and first appeared on a map of the region drawn by Thomas Comberford in 1657, who designated it as Hariots Island. Later, the island took on the name of Batts Island in honor of Nathaniel Batts, who was the first person from Virginia to officially receive a grant for land in what is now North Carolina. The island was sometimes known as Batts Grave. According to legend, the latter name is in honor of the fact that Batts was buried on his island, and is reputed to still haunt the place. As the story goes, he married Kickowanna, a daughter of the chief of the Chowan Indians. She died nearby when her canoe was capsized during a storm as she was paddling across Albemarle Sound. After this tragic episode, Batts never left the island, dying shortly thereafter while mourning the loss of his Indian bride.

## Chapter 2

# The Cape Fear and Its Tributaries

Cape Fear Basin contains over nine thousand square miles of land and is the largest drainage basin entirely within the bounds of North Carolina. Streams in the drainage system flow across the Piedmont, Sandhills and Coastal regions of the state. However, no tributaries of the Cape Fear drain the mountains of western North Carolina.

BLACK RIVER begins at the junction of Coharie River and Six Runs Creek in southern Sampson County. The river traces a serpentine path across Sampson, Bladen and Pender Counties as it makes its way south to its junction with the Cape Fear at Roan Island. According to the U.S. Army Corps of Engineers, the river is sixty-six miles long.

Much history was played out along the Black River from the earliest days of settlement until modern times. The Widow Moore's Creek, site of an important battle in the early days of the American Revolution, is a tributary of Black River.

The ancient bald cypresses that are found growing along the banks of the Black have brought worldwide recognition to this river. Scientists have discovered that these stately old trees are the oldest trees in the Eastern United States. Some of the oldest trees are estimated to be as much as 1,700 years old. Most of these old stands of bald cypress have been protected thanks to the work of the Nature Conservancy and the State of North Carolina.

# NORTH CAROLINA RIVERS: FACTS, LEGENDS AND LORE

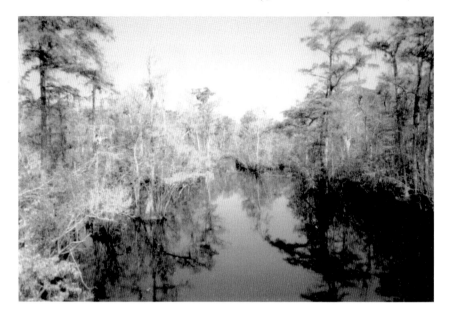

The Black River in Pender County, near the mouth of Moore's Creek.

In 1994, the state designated the waters of Black River as Outstanding Resource Waters.

Black River takes its name from the color of its waters, which contain a high concentration of tannin from the decaying vegetation along its banks that stain the waters. Some of the old maps refer to this as "Black or Swampy River."

When the area was first settled, what we call South River today from its source in Harnett County all the way to the Cape Fear was considered to be Black River. From the junction of Black and South Black Rivers up to the junction of Little Coharie Creek and Great Coharie Creek was called the Coharie River.

BRUNSWICK RIVER begins where the Cape Fear meets Eagle Island above Wilmington. The Cape Fear divides, and the branch flowing on the western side of the island has acquired the name Brunswick River. Its total length is less than six miles.

When Captain William Hilton was exploring the river in 1662, he named this branch of the river for himself. Thus, it was known briefly as Hilton's River. According to James Sprunt, the Brunswick was once considered the main branch of the Northwest Cape Fear and the Northeast Cape Fear did

# THE CAPE FEAR AND ITS TRIBUTARIES

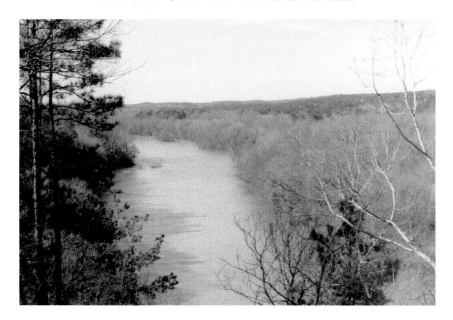

The Cape Fear River in Harnett County, just upstream from Raven Rock.

not end until it reached the end of Eagle Island. The branch that flowed on the east side was known as the "Cutthrough" or "Throughfare." Today, the main channel is considered to be the "Cutthrough." Like the county of the same name, the river ultimately derives its name from King George I, who was duke of Brunswick as well as king of England.

CAPE FEAR RIVER begins in Chatham County at the confluence of Deep and Haw Rivers at a place known as Mermaid's Point, a long sandbar that separated the waters of the two parent streams. There, it was possible to distinguish the reddish-colored waters of the Haw from the much clearer waters of the Deep. According to legend, this point of land where the Cape Fear officially begins was the gathering place for mermaids.

Tradition maintains that mermaids, those half-woman half-fish creatures of sea lore, were reputed to be frequent visitors to this spot nearly two hundred miles from the ocean. What compelled them to leave their normal haunts for this out-of-the-way place? The story goes that when the mermaids grew tired from swimming about in the salt water of the Atlantic, they would head up the mighty Cape Fear to wash the salt from their hair. They would make it all the way upstream to this sandy spit at the junction of the aforementioned rivers. Once there, they would climb up on the sandy point

to dry themselves. Many claimed that it was even possible on certain evenings to hear the mermaids singing their tranquil tunes.

Unfortunately, with the construction of the Buckhorn Dam and the creation of Buckhorn Lake in the early part of the twentieth century, the long sandy spit that gave rise to the legend of Mermaid's Point is no longer visible.

From Mermaid's Point, the river flows in a southeasterly direction past Raven Rock State Park and Lillington. Near Erwin, the river bends back to the south and flows for ten miles to the Bluff in Cumberland County, then bends back to the southwest and south as it flows past Fayetteville. Below Rockfish Creek, the Cape Fear takes more of a southeasterly course as it flows through Bladen County, past Elizabethtown and into Columbus County. The river unites with the Northeast Cape Fear at Wilmington and turns to the south. The river continues south twenty-eight miles past the historic town of Southport and enters the ocean between Bald Head Island and Oak Island, in Brunswick County.

Stretching two hundred miles across the southeastern portion of the state between Mermaid's Point and Bald Head Island, the Cape Fear River is the longest river that flows entirely within the bounds of North Carolina and empties directly into the sea. On an average day, the river contributes six billion gallons of water to the Atlantic Ocean.

The Cape Fear River has a long and distinguished lighthouse history. Down through the years, several structures have stood along this dangerous stretch of coast either to help guide mariners into the Cape Fear River or to avoid the place altogether and steer clear of the treacherous waters of Cape Fear and the Frying Pan Shoals.

Bald Head Island is a wooded island covered with a maritime forest situated on the eastern side of the mouth of the Cape Fear River. The island, which was originally known as Smith's Island, takes its unique name from the headland that rose above the southwest corner of the island that was referred to by mariners as Bald Head. This headland was devoid of vegetation, and the light color of the sandy promontory stood out from the dark hue of the island's trees. According to local lore, river pilots patrolled the top of the hill eagerly awaiting the chance to guide a ship into the mouth of the river, and were thus responsible for keeping the vegetation worn away. Folks began referring to the point as Bald Head, and eventually the name came to be used to refer to the entire island.

A prominent landmark on the island is "Old Baldy," one of the state's most recognized lighthouses. Although this lighthouse is the oldest standing along the North Carolina coast, the island's rich

## The Cape Fear and Its Tributaries

lighthouse history predates construction of this famous structure that was built in 1817.

In the year 1784, the North Carolina General Assembly passed a law that established several rules for navigation on the Cape Fear River from Negroehead Point to the sea. The law set rates for pilotage and established several regulations concerning the pilots who guided vessels into the river. It also levied a duty of six pence per ton on incoming vessels to raise money for a lighthouse.

The law stipulated that the structure was to be built "at the extreme point of Bald-head or some other convenient place near the bar of said river, in order that vessels may be enabled thereby to avoid the great shoal called the Frying-Pan." The commissioners took this instruction literally, and by 1789 were constructing a lighthouse and keeper's quarters on the western edge of Bald Head Island precariously close to the point where the Cape Fear River met the sea. The commissioners obtained ten acres of land for the lighthouse on "Cape Island" from Benjamin Smith, who would later gain notoriety for his service as governor of North Carolina.

Several problems plagued construction of the lighthouse. Commissioners contracted with Thomas Withers for the delivery of 200,000 bricks for the lighthouse. However, due to some unfortunate circumstances, which Withers described as "the stranding of some Vessels, sickness and other fortuitous circumstances," he was unable to deliver the bricks as agreed. So the general assembly granted him an extra allowance for more bricks to complete the project.

In November of 1789, after North Carolina officially joined the United States, the lighthouse project came under the jurisdiction of the U.S. Treasury Department. The following year, the state officially ceded the ten-acre tract with the lighthouse to the federal government. Congress appropriated $4,000 to complete the lighthouse in 1792, but numerous delays plagued the effort. Historian David Stick noted that Abishai Woodward, a carpenter from Connecticut, was employed to build the structure, and George Hooper of Wilmington, a "Commissioner of Navigation," oversaw construction.

The lighthouse was finished and ready for operations by December of 1794. Hooper and his friends were way over budget on the project. The total bill for construction of the lighthouse came out to $11,359.14, more than $7,000 greater than the amount originally appropriated.

In the summer of 1795, the U.S. Treasury Department ran the following announcement several times in the Wilmington newspapers to inform the public about the lighthouse on Bald Head Island:

# NORTH CAROLINA RIVERS: FACTS, LEGENDS AND LORE

>  Cape Fear Light House *is situated near Bald Head, a noted bluff on Cape Fear Island, at the mouth of Cape Fear River, on which river is built the town of Wilmington, in North Carolina. The iron lantern is ten feet nine inches in diameter, and about fifteen feet nine inches in height, from the floor to the top of the roof. It was first lighted on the night of 23d December 1794.*
>
> *The light house bears W.N.W.—From the point of the Cape four miles distant; and N.W. by N. from the extremity of Frying Pan Shoals, distant eight leagues.*
>
> *In sailing from the Eastward, bring the light to bear N.N.E. and then steer in North, which will carry a vessel clear off the shoal, and bring her a short distance off the bar. Observe, however, if it is in the night, out to come into less than seven fathom water.—If there is a necessity of sailing over the bar, without a pilot, bring the house to bear North, or N. half East, and steer directly in for it, until the vessel is close in with the beach, and then for the fort, which bears from thence about North, and is plainly in sight.*
>
> *The channel over the bar is direct, and of a good width.*
>
> *It may be farther necessary to observe to strangers, especially in a dark night, it is most prudent to steer west in lat. 33° 20, or 25 at most, until they shoal in their water to seven or eight fathoms. By doing this, they may be sure of being to the westward of the bar.*

The 1798 edition of Edward Furlong's *American Coast Pilot* included directions for mariners using the lighthouse to enter the mouth of the Cape Fear. "The Light-House, which was erected in December 1794, bears N.N.W. 4 miles from the point of Cape Fear, and 24 miles N.W. b. N. from the extremity of Frying-Pan Shoal."

On a stormy day in July of 1806, an unknown artist sketched a waterspout at the mouth of the Cape Fear, just off Bald Head. He noted that it was one of eleven that were observed in the river that day between 1:00 and 2:00 p.m. Thanks to his desire to chronicle this meteorological phenomenon, the artist left the only known drawing of the original lighthouse on Bald Head Island.

Later that same year, tragedy struck the old Bald Head Lighthouse. Historian Stick wrote in his book, *Bald Head: A History of Smith's Island and Cape Fear*, that light keeper Henry Long was accidentally killed in a hunting accident in October of 1806.

## The Cape Fear and Its Tributaries

As the years passed, the Cape Fear River and the Atlantic Ocean combined to eat away the sandy shoreline opposite the lighthouse. Since the structure had been built so close to the edge of the water, it was only a matter of time before the brink building was in danger of being claimed by the sea. By 1813, erosion of the sandy land along the base of the tower made it necessary for treasury authorities to tear down the Cape Fear's original lighthouse.

Between Mermaid's Point and Little River, the Cape Fear flows across the Fall Line from the Piedmont onto the Coastal Plain. The elevation of the river at Mermaid's Point is 152 feet above sea level. The river descends 85 feet as it crosses the Fall Line, dropping from an elevation of 135 feet above sea level at Buckhorn to 50 feet above sea level at the mouth of Lower Little River. This is an area of rocks and rapids that impeded river navigation in the days of old. Several of the rapids in this area contain colorful names, such as Buckhorn Falls, Northington's Falls and Shaw's Great Falls.

The two-mile section between Narrow Gap and the Erwin Bridge contains a system of rapids known collectively as Smiley's Falls, where the river drops twenty-five feet as it dashes thorough a series of rock outcroppings. Old Averasboro was built on the east bank of the river at the foot of Smiley's Falls, as it was the head of pole boat navigation on the river. It is a ghost town now, but in its prime it was the third largest settlement on the Cape Fear. Just upstream is Erwin, where Benjamin Duke and his associates built what became the largest denim factory in the world. They chose the site in order to harness the power of Smiley's Falls, but opted to use the oil-powered generators, which were cutting-edge technology in the beginning of the twentieth century.

The U.S. Army Corps of Engineers operates three sets of locks and dams as part of their efforts to maintain a navigable channel in the river between Fayetteville and Wilmington. Located in Bladen County, these dams are William O. Huske Locke, Lock & Dam #2 and Lock & Dam #1.

The section of the river between Wilmington and the sea is steeped in history and lore. Town Creek, on the west side of the river in Brunswick County, was named for the town established along its shores in the mid-1660s that was settled briefly by a group of colonists from Barbados. Just downstream is Brunswick Town, an abandoned town that served as an important port and commercial center in the mid-1700s. Founded in 1725 by Maurice Moore, the town declined as Wilmington grew, and was abandoned after it was burned during the Revolutionary War. On the east side of the river are the remains of Fort Fisher, scene of a series of important battles in the final days of the War Between the States.

# NORTH CAROLINA RIVERS: FACTS, LEGENDS AND LORE

The foot of Smiley's Falls on the Cape Fear River near Erwin. The old town of Averasboro once stood along the eastern bank of the river near here.

The ruins of old Brunswick Town on the west bank of the Cape Fear River near Southport.

## THE CAPE FEAR AND ITS TRIBUTARIES

The river takes its name from Cape Fear, one of three sandy promontories that jut out of the North Carolina coast. The cape was originally called Cabo de Trafalgar by the Spaniards. Both Sir Richard Grenville and John White, prominent sixteenth-century English explorers, nearly wrecked upon what they referred to as "the breach called Cape of Fear." Later, on a map published by Theodore DeBry in 1590, the place is labeled as "Promontorium Tremendum." Some hypothesize that the English explorers were actually on Cape Lookout instead of Cape Fear when they nearly wrecked their ships, but this is uncertain. Regardless, the name Cape Fear stuck to the point on Bald Head Island that is still designated as such today.

The Spaniards also called this river the Rio Jordan, after the famous River Jordan mentioned in the Bible. To the English settlers, the river has been called alternately the Hilton River, Green River, Clarendon River, the Charles River, the Cape Fair River and the Cape Fear River. Above Eagle Island, where the river forks into two branches, the two branches were called, respectively, Northwest Cape Fear and the Northeast Cape Fear.

COHARIE RIVER begins in central Sampson County where Little Coharie Creek and Great Coharie Creek unite. These streams drain most of northern Sampson. The Coharie flows about six miles until it intersects with Six Runs Creek, at which point Black River begins.

In the early days of the colony, the Coharie was much longer, being the designation for the watercourse all the way to its confluence with South River. For reasons unknown, the name Black River was applied to the stream from the mouth of Six Runs downstream, so the Coharie is now only a short river. Some believe this was simply a case of mistaken identity on the part of a colonial surveyor.

The ghost town of Lisburn, Sampson's first town, was established near the mouth of the Coharie in 1785. It was named for Lisbourne, Northern Ireland, a town in the region from which many of Sampson's early settlers migrated. The location of the town was at the head of navigation on the Coharie and was a thriving settlement in the days when waterways served as the main transportation arteries, and people utilized this river to transport naval stores to Wilmington. Thus, when riverborne traffic died down in the 1800s, so did the town.

According to Sampson County historian Oscar Bizzell, the name Coharie is an Iroquois word meaning "driftwood," and is derived from the same word as the Schoharie River in New York.

# NORTH CAROLINA RIVERS: FACTS, LEGENDS AND LORE

Faith Rock on the Deep River at Franklinville in Randolph County. According to legend, Andrew Hunter made a daring escape from Colonel David Fanning's band of Loyalists by riding his horse down the face of this rock.

DEEP RIVER begins at the confluence of West Fork Deep River and East Fork Deep River near High Point. The river flows over 125 miles across central North Carolina, first heading south across Randolph and Guilford Counties to northwestern Moore County. Near High Falls, the Deep makes a sharp bend to the northeast and meanders in that general direction until its junction with the Haw. The elevation of the headwaters of the Deep River is over 800 feet above sea level, and the elevation at its mouth near Moncure is 160 feet. According to the U.S. Army Corps of Engineers, the Deep drains 1,440 square miles of land and carries 936 million gallons of water each day into the Cape Fear.

The origins of the name are uncertain, but it dates back to at least the 1720s, when the name began appearing on maps of the region. The Deep River Valley is renowned for its deposits of valuable natural resources, including iron and copper. The most famous of these resources is the Deep River coal, which was mined at such places as Cumnock and Gulf.

A large rock outcropping rises above the Deep River as it passes by the town of Franklinville in Randolph County. Known as Faith Rock, this

## The Cape Fear and Its Tributaries

place has been a prominent landmark along the river since the waning days of the Revolutionary War.

In the spring of 1782, long after the surrender of the British army under Cornwallis at Yorktown and the subsequent evacuation of Wilmington, Colonel David Fanning decided that it was time for him to depart North Carolina and seek refuge with the British garrison at Charles Town, South Carolina. The wily Loyalist was not willing to depart for Charles Town, however, without having a farewell party with his men.

"I concluded to have a frolic with my old friends before we parted," he later recalled in his reminiscences about the war. In an effort to obtain some alcoholic beverages, on May 2, 1782, he set out in pursuit of a wagon he had learned the day before was heading for market on the Pee Dee in South Carolina.

The wagon was overtaken eleven miles away. Walking alongside the wagon was John Latham, who lived on Little River in southern Randolph County. Fanning had no quarrel with Latham, but was merely in search of provisions. When he inquired of the wagon's contents, Latham told him, "Some flaxseed, beeswax, etc." When asked if he had any food, Latham replied in the affirmative but told Fanning he hoped the Loyalists wouldn't take it from him as there was little to eat along the way.

Heedless of the man's request, Fanning bound onto the wagon to search for provisions. As he flung back the tarp, he was surprised to find not only food but a person—Andrew Hunter. Hunter was accompanying his neighbor to market, and as soon as they saw the Loyalist raiders approaching he hid under the tarp. Seems that Hunter was a Whig and had violated his parole sometime in the past, and knew what would happen to him if he were captured by Fanning.

Now his worst dreams had come true, for not only had he been discovered, but he had been recognized by the fierce Loyalist raider. "Ah! You infernal rascal—I have you now," the Reverend Eli Carruthers records Fanning saying. "Come out here, and be saying your prayers as fast as you can; for you have very few minutes to live."

Of more immediate concern to Fanning's men were the provisions, and they prevailed upon their leader to postpone the execution until after lunch. A rope was flung down at Hunter's feet, and he was told that he had fifteen minutes to live.

As the Loyalists feasted, Hunter stood nearby, frantically eyeing every avenue of escape. He cast a glance at the weapons stacked nearby, but his plan to seize a weapon was thwarted when Fanning told his men, "Stand

by your guns, or that rascal will get one and kill some of us before we know what we are about."

Abner Smally finished his meal before his comrades and walked over to converse with the condemned man, whom he apparently already knew. Hunter asked if he could perhaps change Fanning's mind, but Smally replied that such was virtually impossible. As they continued talking, they walked a few feet away from the dining Loyalists and closer to their horses, hastily tethered on some bushes.

Seeing this as perhaps his last opportunity to escape, Hunter bound onto the nearest horse, which just happened to be Fanning's favorite mare, Red Doe, or Bay Doe as she is sometimes known. At first, the horse stood still as orders were shouted to kill Hunter. A shot was fired. The bullet missed its target, and the horse bolted.

Fanning warned his men to shoot high and not wound the valuable beast. As he galloped off, Hunter laying close to the horse, more shots were fired. Captain Carr finally hit the target, but it was too late. Hunter had escaped on Fanning's favorite horse, carrying away the pistols he had received from Major Craig and all his important papers.

Fanning was unable to track the fugitive, and after only a short chase returned and ordered Latham to guide the Loyalists to Hunter's house. Fanning seized Hunter's wife, three slaves and eight horses before returning to his lair along Deep River. He sent Latham to tell Hunter that he would exchange all of this booty for Red Doe and his papers.

A few days later, Hunter sent Fanning a reply, stating that the horse had been sent west to bring back medical help, but would be returned as soon as possible. He also asked Fanning to release his wife, since he was wounded and needed her to look after him.

Fanning realized that this was merely an effort to stall for time, and that he would probably never see Red Doe again. Realizing that it was well nigh impossible to retrieve his valuable horse with so little time, Fanning released all of Hunter's horses except one. He did compensate himself, however, by keeping an unspecified number of Hunter's slaves. Mrs. Hunter was also freed.

Fanning's efforts to personally recapture his valuable mare ended unsuccessfully in the fall of 1782 when Andrew Hunter eluded him in South Carolina. But some of Fanning's men who were left behind in central North Carolina in the waning days of the war kept an eye out for the elusive Hunter. One day, they came across him on the west side of the Deep River near Cox's Mill.

## The Cape Fear and Its Tributaries

Once he spotted the Loyalists, the desperate man tried frantically to elude his pursuers. Though he was mounted on a swift horse, his escape route over the Buffalo Ford was blocked by Fanning's men. Hunter turned north, but after a while he was cut off by another of Fanning's comrades.

Hunter turned his beast into the woods in an effort to cross Deep River. When he emerged from the trees he found that he was at the top of a steep, rocky cliff that descended sharply to the boisterous waters of the Deep. His pursuers were closing in, so Hunter made a bold decision.

In a remarkable display of horsemanship, Hunter rode Red Doe down the face of the rock, and from the ledge jutting out over the water, horse and rider plunged into Deep River. They somehow negotiated the turbulent, rock-strewn stream and emerged safely on the north side.

His Loyalist pursuers drew up at the top of the cliff and watched Hunter's descent into the river below. Declining to imitate the desperate man, they fired a few parting shots at him as he dashed off to safety in the woods across the Deep River.

To this day, the rock outcropping down which Hunter made his daring and reckless dash to freedom is still known as Faith Rock.

EAST FORK DEEP RIVER rises near Friendship in Guilford County and flows east then south into Lake High Point at Jamestown, where it unites with the West Fork Deep River.

ELIZABETH RIVER rises west of the Brunswick County Airport and flows east into the Cape Fear. It joins the Cape Fear south of the town of Southport, once one of North Carolina's busiest harbors. Legend states that the Elizabeth River was a favorite haunt for the pirates and sea rovers who once infested this part of the colonies. Today it is important as one of the streams that is followed by the Intracoastal Waterway.

HAW RIVER begins at a spring just north of Kernersville and flows northeast toward the Roanoke River drainage system. But at the ridge near Thompsonville in Rockingham County the river is deflected to the southeast and thus remains in the Cape Fear Basin. On its journey of more than 135 miles, the Haw passes through the counties of Forsyth, Guilford, Rockingham, Alamance, Orange and Chatham. According to the U.S. Army Corps of Engineers, the Haw drains 1,695 square miles of land and on a daily basis contributes 1,200 million gallons of water into the Cape Fear.

# NORTH CAROLINA RIVERS: FACTS, LEGENDS AND LORE

The Haw River near Bynum in Chatham County.

The Haw River takes its name from the Saxapahaw, a tribe of Indians who once lived along its banks. The river itself was once called Saxaphaw River, and the upper Cape Fear, as far down as the mouth of Lower Little River, was frequently referred to as the Saxapahaw River in the mid-1700s. The name has been shortened to Haw, and the river now officially ends at its junction with the Deep.

Dr. Douglass Rights, an authority on the Indian tribes of North Carolina, maintained that these people were the same folk as the "Cacores" described by Francis Yardley of Virginia in 1654. When speaking of their relationship with the more powerful Tuscaroras, Yardley noted the Cacores as being "very little people in stature, not exceeding youths of thirteen or fourteen years, but extremely valiant and fierce in fight, and above swift in retirement and flight, whereby they resist the puissance of this potent, rich and numerous people."

Dr. Rights then observed, "This tribe of valiant little men may have been the Shoccorree, or Shakori, living westward, probably in the region of Haw River. Saxapahaw is another rendering of their name. It is interesting to note that in lower Randolph County on Cedar Creek, within Shocoree territory, several graves were disturbed by waters of a freshet in 1929, revealing skeletal remains of Indians small in stature whose teeth indicated that they were past middle age."

# THE CAPE FEAR AND ITS TRIBUTARIES

The Northeast Cape Fear River near Kenansville.

The B. Everett Jordan Dam is the most prominent feature on the Haw River today. Completed in 1982, the dam is 1,330 feet long by 800 feet wide. The dam was built across the Haw at the mouth of New Hope River, and backs up the waters of Haw River nearly five miles.

LITTLE RIVER rises in southwestern Moore County near West End and flows east to its junction with the Cape Fear at Linden. The river drains 448 square miles of land in the Sandhills region of the state.

It forms a large portion of the border between Harnett and Cumberland Counties. This river is also known as Lower Little River to distinguish it from nearby Upper Little River.

NEW HOPE RIVER rises between Durham and Chapel Hill and flows south/southwest to its junction with Haw River. The drainage basin for this river is 317 square miles. Much of this river is inundated by the waters of B. Everett Jordan Lake.

NORTHEAST CAPE FEAR RIVER rises near Mount Olive and flows east, forming the boundary between Wayne and Duplin Counties to near Gradys, where it begins a gradual turn to the south. The river flows south beyond Chinquapin, where it bends to the west then southwest.

# NORTH CAROLINA RIVERS: FACTS, LEGENDS AND LORE

The Rocky River joins the Deep River in Chatham County. The area along the mouth of the river is a part of the Triangle Land Conservancy's White Pines Preserve.

It meanders south by the Angola Game Reserve and the Holly Shelter Game Land before heading west near Rocky Point. It turns south beyond Castle Hayne and flows to unite with the Cape Fear at Negroehead Point at Wilmington. The Northeast Cape Fear is over 125 miles long and drains 1,330 square miles of land.

# The Cape Fear and Its Tributaries

Upper Little River, near where it begins in Lee County south of Sanford.

This river was considered to be the main branch of the Cape Fear River by William Hilton and his men when they were exploring the region in the early 1660s. This was soon found to be an error, so the branches were designated Northwest Cape Fear and Northeast Cape Fear. Eventually "Northwest" was dropped, but the Northeast Cape Fear retained its designation.

NORTH PRONG ROCKY RIVER rises north of the town of Liberty and flows east into Alamance County then turns south into Chatham County. It bends southeast and enters the Rocky River east of Staley.

ROCKY RIVER rises at the town of Liberty in Randolph County and flows southeast into Chatham. It flows by Siler City and continues to a point northeast of the community of Cumnock, where it enters Deep River.

The area through which the Rocky flows in Chatham was renowned for its mineral resources. There were a number of mines in production here in the late 1800s.

A set of shoals is located on Deep River at the mouth of the Rocky. The drop here was once utilized by the Clegg family to power a mill.

# NORTH CAROLINA RIVERS: FACTS, LEGENDS AND LORE

The South River at Falcon.

The Rocky derives its name from the large number of boulders in its channel. Many canoeists like to try their luck on this stream, especially when the water is high.

SOUTH BLACK RIVER rises near the town of Angier in Harnett County and flows south to unite with Black River near Ivanhoe in Sampson County. The

river drains 1,430 square miles of land. The river gets the name Black from the large amount of tannic acid released into its waters by rotting vegetation.

In Harnett County the stream is known by its original name—Black River. The name changes to South River at the Sampson line, as citizens of that county had another Black River when the county was formed in 1784, so the one originating in Harnett became South Black River. Today

# NORTH CAROLINA RIVERS: FACTS, LEGENDS AND LORE

The West Fork of the Deep River joins the East Fork of the Deep River to form the Deep River. The spot is now a part of High Point Lake.

the "Black" has been dropped and it is commonly known as South River beyond Rhodes' Pond. It becomes Black River again once it unites with the other stream of that name.

UPPER LITTLE RIVER begins in Lee County where Little Juniper Creek and Mulatto Branch unite. The river flows into Harnett and the majority of its existence is in this county. Upper Little River flows over a rock ledge and into the Cape Fear at Smylie's Falls near Erwin. This river's drainage basin is 176 square miles.

The term "Upper" is applied to distinguish this river from its counterpart, Little River or Lower Little River, which flows into the Cape Fear five miles downstream from Smylie's Falls.

One interesting landmark on the river is mentioned in the Cumberland County records as early as 1759. The shoals that are near the North Carolina 210 bridge today were then referred to as "Great Falls of Little River." This was the site of various gristmill operations for over two hundred years, including that of "Sober John" McLean, who is buried nearby.

WEST FORK DEEP RIVER rises in Forsyth County and flows east then south into Lake High Point. Here it unites with the East Fork Deep River and forms the Deep River.

CHAPTER 3

# Rivers of the Mississippi Watershed

THE MISSISSIPPI RIVER BASIN contains 1,243,700 square miles of land. This is one-eighth of the North American continent. The basin contains thirty-one states in the United States and two provinces of Canada.

The OHIO RIVER BASIN contains 203,900 square miles and drains the states of Pennsylvania, Ohio, West Virginia, Kentucky, Indiana, Illinois, Tennessee, Georgia, Alabama, North Carolina, Mississippi and Virginia. The Ohio joins the Mississippi at Cairo, Illinois.

North Carolina's tributaries to this system reach the Ohio, and ultimately the Mississippi, through either the Tennessee River or the Kanawa River. The vast majority of the rivers in the western part of the state flow west into the Tennessee. However, one notable river basin on the western side of the Eastern Continental Divide carries its water north to the Ohio.

The TENNESSEE RIVER BASIN contains 40,910 square miles of land in Georgia, North Carolina, Alabama, Tennessee, Kentucky, Mississippi and Virginia. The Tennessee River joins the Ohio at Paducah, Kentucky. The headwaters of the Tennessee River drain some of the most rugged country of the Eastern United States. The Toe and Cane Rivers drain the slopes of Mount Mitchell, North Carolina, the highest peak in the Eastern United States. Other rivers, such as the Nolichucky and Watauga, flow through some of the steepest, wildest gorges this side of the Grand Canyon.

The Tennessee River was once a wild river, with many shoals and rapids to impede navigation and pose a potential hazard to travelers along this

## NORTH CAROLINA RIVERS: FACTS, LEGENDS AND LORE

watercourse. In addition, those who lived in towns and settlements along the river were frequently subjected to catastrophic floods. In the early twentieth century, the federal government took on the task of taming this wild river. To accomplish this, the Tennessee Valley Authority (TVA) was formed in 1933.

Thanks to the work of the TVA and the U.S. Army Corps of Engineers, the waters of the Tennessee have been tamed. The TVA has constructed forty-nine dams along the Tennessee and its various tributaries. The system of dams and reservoirs serve many purposes, but the most important are flood control and hydroelectric power.

Four TVA hydroelectric dams are located in North Carolina—Apalachia, Hiwassee, Fontana and Chatuge. They have a combined power generation capacity of 532 megawatts. The reservoirs from these dams have a combined surface area of 24,880 acres, with 574 miles of shoreline.

BEECH FLATS PRONG rises in Newfound Gap and flows east/southeast to unite with Kephart Prong to form the Ocanaluftee River.

BLOOD RIVER rises on Lamb Knob three miles southwest of the town of Hot Springs in Madison County. It flows north about five miles and empties into the French Broad; it is the last tributary of the latter before it crosses over into Tennessee.

BRADLEY FORK RIVER rises on Porter's Mountain in the Great Smoky Mountains National Park and flows south by Richland Mountain. It joins the Oconaluftee River near the Smokemont Campground.

CANE RIVER rises in the high reaches of the Black Mountains of southern Yancey County. The river begins at the junction of Beech Nursery Creek and Blue Sea Creek. It flows west around the base of Big Pine Mountain, then bends north and flows in that general direction through the communities of Pensacola and Vixen. As it passes through the gap between Bowlens Pyramid and Beebranch Mountain, the river bends west and flows along the south side of the town of Burnsville. The river is approximately twenty miles in length.

The river continues west to the community of Cane River, where it resumes its course in a northerly direction until it reaches the Lewisburg community, at which place the river bends back to the northeast and unites with the Toe River to form the Nolichucky.

# Rivers of the Mississippi Watershed

Cheoah River begins at the junction of Tulula Creek and Sweetwater Creek near Robbinsville. Its course is northwest across Graham County between the Cheoah Mountains and the Unicoi Mountains. The river joins the Little Tennessee near Cheoah Dam.

Santeetlah Dam was built across the Cheoah River in 1927, creating the nearly three-thousand-acre Santeetlah Lake. Water is piped by the Tennessee Valley Authority from Santeetlah Lake to the powerhouse on the Little Tennessee to generate electricity. Hence, the Cheoah below Santeetlah Dam is only a shadow of its former self, sometimes little more than a dry riverbed.

The Cheoah derives its name from the Cherokee word "tsiyah," which James Mooney notes means "otter place."

Cullasaja River rises on the Blue Ridge near Highlands. The headwaters are dammed up to form Ravenal Lake, but once the river leaves the lake it flows southwest across High Falls. It veers west at Little Bear Mountain and flows into the backwaters of Lake Sequoyah. Downstream from the dam, the river flows through the rugged Cullasaja Gorge. Most of the river's route through the gorge is followed by U.S. 64. The river joins the Little Tennessee at Franklin.

Along the route, the river plunges over several picturesque cascades, including Bridal Veil Falls, Dry Falls and Cullasaja Falls.

According to Mooney, the name is believed to be a corruption of the Cherokee word "Kulsetsiyi," which means "honey locust place."

Dark Prong rises on Black Balsam Knob and flows east to its junction with the Yellowstone to form the East Fork Pigeon River.

Davidson River heads up in the Pisgah Mountains of northern Transylvania County. It flows generally east/southeast until it empties into the French Broad River at the town of Pisgah Forest near Brevard.

The Davidson River flows through the Pisgah National Forest, and both it and its feeder streams offer many recreational opportunities. Numerous campgrounds are located along its banks, and nearby is Looking Glass Mountain, a granite dome that rises over 1,700 feet above the surrounding forest.

On the upper reaches of the Davidson River, at its junction with Grogan Creek, is the Bobby N. Setzer State Fish Hatchery. This is the largest trout hatchery in North Carolina. It was built in the 1950s by

# NORTH CAROLINA RIVERS: FACTS, LEGENDS AND LORE

the U.S. Fish and Wildlife Service, but has been operated by the North Carolina Wildlife Resources Commission since 1983.

Also located nearby are two famous waterfalls, Looking Glass Falls and Sliding Rock, both on Looking Glass Creek, a tributary of the Davidson. Looking Glass Falls is an 85-foot cascade, while Sliding Rock gradually drops 150 feet down a granite incline. It is a popular spot for hot tourists in summer. Many old maps once referred to the latter as Slick Rock. Another tributary is Laurel Fork, which descends more than 1,400 feet in a mile before joining the Davidson River at Laurel Fork Shoals.

The Davidson River descends gradually down to the French Broad, being interspersed with many small shoals.

The earliest name for the river was Ben Davidson's River. The river was named for a settler, Benjamin Davidson, who took out land along its shores in the 1780s. Eventually the first name was dropped, and the river's name was shortened to Davidson River.

EAST FORK FRENCH BROAD RIVER begins on the Blue Ridge near Feed Rock and the South Carolina border. It flows in a westerly direction to its junction with the French Broad at Rosman. One of its feeder streams, West Fork of Gladys Fork Creek, is the location of the impressive Buttermilk Falls, so named because the turbulent water is whipped into a white froth as it follows a steep grade over many rocks.

EAST FORK PIGEON RIVER begins at the junction of Yellowstone River and Dark Prong in the Shining Rock Wilderness Area. It flows north between Blue Ridge and Cold Mountain, then bends west/northwest near Rocky Face Mountain and unites with the West Fork Pigeon River at Silver Bluff to form Pigeon River. This river is sometimes known as Big East Fork Pigeon River.

ELK RIVER rises in Avery County near the town of Banner Elk and flows northwest into Tennessee. It flows into Lake Watauga, where its waters join those of Watauga River.

During its course, the Elk passes over a ninety-foot fall known as Elk River Falls. This is a seldom-visited site due to its remoteness, yet many travelers do persevere and are rewarded for their efforts.

The Elk flows through the resort town of Banner Elk. This town was named for the Banner family, who settled along the Elk in the early 1800s. The settlement was once known as Shawneehaw, but its name was changed to Banner Elk in 1911.

# RIVERS OF THE MISSISSIPPI WATERSHED

The view from the top of Paint Rock looking down at the French Broad River as it passes from North Carolina into Tennessee.

# NORTH CAROLINA RIVERS: FACTS, LEGENDS AND LORE

FRENCH BROAD RIVER begins at the junction of West Fork French Broad River and the North Fork French Broad River at Rosman in Transylvania County. The river meanders across a wide valley in a northeasterly direction to Brevard. The river flows northeast, then bends back to the north near Mills River and flows to Asheville. As the river nears Asheville, it flows by the Biltmore Estate.

From Paint Rock, the French Broad continues 102 miles to its confluence with the Holston River at Knoxville, where the Tennessee River officially begins. The mouth of the French Broad River is 652 miles upstream from the mouth of the Tennessee River.

From Rosman in Transylvania County to the Tennessee border, the French Broad is 116 miles in length. The total distance covered by the stream from Rosman to the confluence with the Holston is 218 miles. The river drains 5,124 square miles of land, which is divided between 1,664 square miles in North Carolina and 3,460 square miles in Tennessee. The river descends from an elevation of 2,200 feet at the beginning of the river at Rosman to an elevation of 1,240 feet at Paint Rock, the river's lowest point in North Carolina.

Along the upper portion of the river, from Rosman to Asheville, a distance of 70 miles, the French Broad flows in a relatively even gradient, descending up to 3 feet per mile. Thus, the river is more reminiscent of streams of the Piedmont than those of the mountains. As the river leaves its high mountain valley and heads west, the rate of descent increases dramatically, descending up to 30 feet per mile in some of the steeper sections of the river between Asheville and Hot Springs. The French Broad drops 714 feet in elevation along the 43 miles from Asheville to Paint Rock.

The French Broad River is a prime example of how sound conservation practices and community involvement can have a positive impact on a community. In the not too distant past, the waters of the French Broad were notorious for being polluted by a host of chemicals that were dumped into the river by a manufacturing plant. Today, thanks to the hard work of a number of individuals along with government and private organizations, the French Broad is recovering, and the river is home to a variety of plant and animal life. Trout, largemouth bass and catfish are regularly caught here by fishermen.

Whence came the name "French Broad?" The name shows up officially in North Carolina records in 1777, when a resolution in the state senate mentions "French Broad River." Prior to that time, there is no official mention of this watercourse, mainly because it would have been

## Rivers of the Mississippi Watershed

considered outside the jurisdiction of the colony and there were thus no land grants issued by British officials.

Most historians agree that the reason for attaching "French" to this Broad River was to differentiate between two rivers of like name that rise in such close proximity to each other yet flow in opposite directions. The Broad River and its tributaries flow south and east to eventually reach the Atlantic, while the French Broad River flows north and west to join the Tennessee and eventually the Gulf of Mexico. The French Broad was thus designated because its waters flow west into the Mississippi, and since France claimed all the land drained by the Mississippi and all its tributaries, was thus considered French territory.

If this is the case, the name must have been given to the river before 1763, when the Treaty of Paris was signed. This treaty, which ended the French and Indian War, ceded France's North American lands to Great Britain. After this point in time, there was no longer any French territory, and no reason or basis for designating a stream as "French."

The name may date back to the early 1700s, when French coureur de bois or fur trappers were probing the tributaries of the Ohio and Tennessee Rivers looking for new sources of furs and new trade routes. It is known that a Frenchman, Jean Couture, charted a route between the French settlements along the Mississippi and South Carolina in the year 1700. The exact path these Frenchmen took is uncertain, and accounts of their activities are sketchy. But a group of Frenchmen who followed the route in the summer of 1701 noted that the route went up to the headwaters of the Tennessee River, and that the waters that flowed east to the Atlantic and the waters that flowed west to the Mississippi were separated by a portage "one and a half leagues."

Which rivers would these voyageurs have followed across the mountains into South Carolina? It is unlikely these traders would have taken the route across the mountains that led up the Little Tennessee and down one of the tributaries of the Savannah, such as the Toxoway or the Davidson Rivers, as the terrain was much too rugged and the gradient of the rivers involved too steep. Although the headwaters of the Tennessee rise among some of the same remote mountains as the headwaters of the Savannah, the character of the latter's tributaries would have limited travel upon any of these watercourses. It is doubtful that such experienced voyageurs would have chosen a route that took them down the steepest part of the Blue Ridge Escarpment and across some of the highest waterfalls in Eastern North America.

The most plausible route for them to have followed would have been up the French Broad to the vicinity of Asheville, where they would have picked

up the old Indian trail across the Blue Ridge into Hickory Nut Gorge, and then followed the next sizable watercourse, in this case Broad River, down into the settlements of South Carolina. Those traveling in the opposite direction would have traveled up Broad River, past the First Broad River and then past the Second Broad River, into Hickory Nut Gorge, across Hickory Nut Gap and down to the waters of the French Broad River, which led them onward toward the French settlements along the Mississippi.

This is just one possibility. A full discussion on the topic of canoe routes and Indian trails across the Blue Ridge is beyond the scope of this work, but it is certain that by the beginning of the eighteenth century Frenchmen were probing around the headwaters of the Tennessee River, including the French Broad River.

HIWASSEE RIVER rises in the Chattahoochee National Forest near the Appalachian Trail southeast of Brasstown Bald in Town County, Georgia. It flows north into North Carolina and turns west downstream from Hayesville, then flows by Murphy and enters Tennessee nearly thirty-five miles downstream. The river then continues west and enters the Tennessee River northwest of Cleveland at Chickamauga Lake.

The waters of the Hiwassee are impounded by three TVA dams in North Carolina. The Hiwassee Dam was the first TVA dam completed along the Hiwassee River. Built between 1936 and 1940, the dam spans 1,376 feet across the river and stands 307 feet tall. The generating capacity of this facility is currently 185,000 kilowatts.

The Chatuge Dam spans the 2,850 feet across the Hiwassee River and stands 144 feet tall. It was constructed by the TVA between 1941 and 1942 to store water for flood control, but in 1954 a hydropower station was added.

The Appalachia Dam spans 1,308 feet across the Hiwassee River and is 150 feet tall. The project was built by the TVA between 1941 and 1943 to generate electric power. Water is carried from the reservoir behind the dam through a system of tunnels to the powerhouse 8.3 miles downstream.

In 1899, Swain and his companions examined the Hiwassee River as a source of water power. They wrote of the river,

> *Below Murphy, the river is a rapid stream, but the fall is well distributed, there being no places where there is any considerable amount of concentrated fall. The distance from Murphy to the North Carolina-Tennessee state line, following the course of the river, is about*

# Rivers of the Mississippi Watershed

*28 miles, and the total fall in the stream is about 300 feet, or between 10 and 11 feet to the mile.*

*Between Murphy and Hayesville, a distance of 19 miles following the course of the river, the total fall is about 250 feet and the average fall per mile about 13 feet.*

The Hiwassee takes its name from the Cherokee word "Ayuhwasi," which denotes a meadow or savannah.

Kephart Prong rises at Icewater Spring on the eastern flank of Mount Kephart and flows northeast to its confluence with Beech Flats Prong. It is named for Horrace Kephart, the famous author who wrote such books as *Our Southern Highlanders*.

Left Fork Raven Fork River rises in the gap between Mount Guyot and Mount Hardison on the North Carolina/Tennessee line in the Great Smoky Mountains National Park. It flows south to its junction with Right Fork Raven Fork River.

Left Fork Swannanoa River rises in Buncombe County in the Great Craggy Mountains between Craggy Dome and Bullhead Mountains. It flows in an easterly direction to its junction with the North Fork Swannanoa River near Buckeye Cove.

Left Prong South Toe River rises at Pinnacle Spring, elevation 5,190 feet above sea level, on the flank of Pinnacle Mountain. It flows in a northerly direction for about three miles before uniting with the Right Prong of South Toe River. The Left Prong South Toe River descends nearly 2,200 feet in its short life.

Little East Fork Pigeon River rises on Shining Rock Mountain and flows north/northwest to unite with West Fork Pigeon River near Sunburst.

Little River (French Broad) rises on the South Carolina border and flows along a northerly course until it joins the French Broad near Pemrose. A boisterous, rock-filled river with several rapids and waterfalls, much of the river is protected within the confines of Dupont State Forest. Several scenes from the film *Last of the Mohicans* were shot along the Little River.

# NORTH CAROLINA RIVERS: FACTS, LEGENDS AND LORE

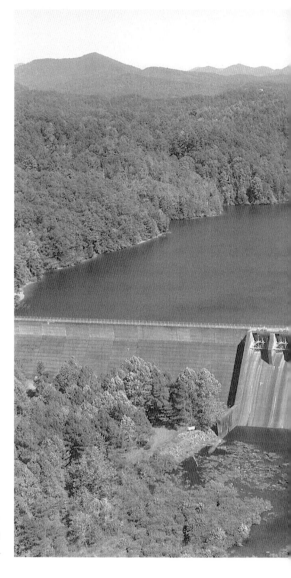

The Apalachia Dam on the Hiwassee River in western North Carolina was completed by the TVA in 1943. *Courtesy of Tennessee Valley Authority.*

Perhaps the best-known spot on this river is Bridal Veil Falls, a 150-foot cascade where the water is spread out in a pattern resembling a bride's veil as it cascades down the sides of the granite rock face, hence the name. Near the top of the falls, the river plunges over a ledge, creating a spot where it is possible to walk behind the falls.

The next waterfall downstream is High Falls. Here the river plunges nearly 160 feet down the face of a granite ledge. Little River next plunges

# Rivers of the Mississippi Watershed

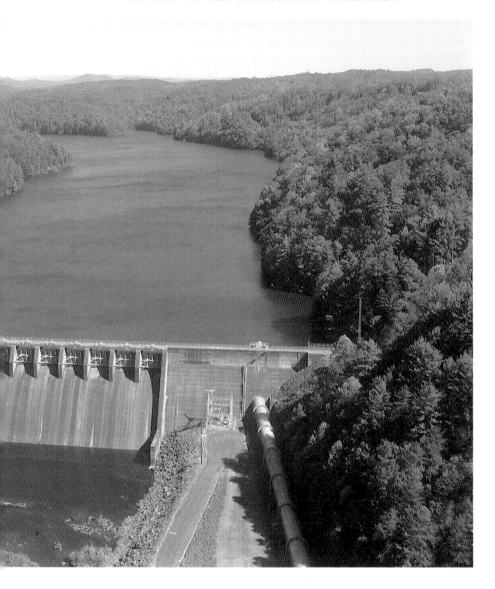

over Triple Falls, a system of three cascades where the river falls a total of 120 feet. The last major waterfall on Little River is Hooker Falls. Here the river drops over nearly 20 feet, culminating in a 10-foot drop into the waters of Cascade Lake.

LITTLE TENNESSEE RIVER begins at the confluence of Billy Creek and Keener Creek near Dickerson Mill in Rabun County, Georgia. The river

# NORTH CAROLINA RIVERS: FACTS, LEGENDS AND LORE

The Cowee Mound overlooks the Little Tennessee River in Macon County.

flows east for approximately three miles, then makes a sharp bend to the north at the confluence with Black Creek at the base of Oakey Mountain. It flows north through the town of Dillard, and crosses the state line into North Carolina five miles north of town.

Twenty miles north of the state line, the river reaches Franklin, the county seat of Macon County. One of the more interesting landmarks along the river in Franklin is the Nikwasi Indian Mound.

Less than a mile downstream from the mouth of the Tuckasegee River, the Nikwasi Mound rises along the west side of the river near the Business 441 bridge in Franklin. A prominent landmark that is pointed out by motorists who pass by the spot on the busy streets of the Macon County seat, this grass-covered hill stood along the shores of the Little Tennessee long before the town of Franklin or Macon County was ever conceived.

# Rivers of the Mississippi Watershed

As a matter of fact, this hill predates the Cherokee, who found the mound standing when they first arrived in the area in the sixteenth century.

The mound takes its name from Nikwasi, the old Cherokee town that stood here for more than two centuries. Nikwasi was considered a sacred town by the Cherokee, and the mound was a very important part of the town. During the years when this was a Cherokee town, a council house stood atop the mound, inside of which a perpetual fire was maintained. Each year, the Cherokee living nearby would douse the fires in their homes and relight them from flames obtained from the priests who maintained the sacred fire that burned deep within the mound.

The Nikwasi Mound is now approximately fifteen feet tall, but in its glory days it was at least twice as tall. The mound was built by the Native Americans of the Mississippian culture. They were often referred to as the Mound Builders because of their penchant for building large earthen mounds in their towns. Fine examples of these mounds can still be seen at Town Creek Indian Mound State Historic Site near Mount Gilead, North Carolina, and at the Etowah Indian Mounds Historic Site near Cartersville, Georgia.

One interesting legend about the Nikwasi Mound claims that it is the abode of a group of immortals known as the Nunne'hi. These beings were always friendly to the Cherokee, and often helped them in times of trouble. On one occasion, the Cherokee were attacked by a group of hostile Indians who invaded their territory and were in danger of being overwhelmed by these invaders. But they were saved by the timely intervention of the Nunne'hi, who emerged from the mound and came to their rescue.

James Mooney described the incident.

> *The Nunne'hi poured out by the hundreds, armed and painted for the fight, and the most curious thing about it all was that they became invisible as soon as they were fairly outside the settlement, so that although the enemy saw the glancing arrow or the rushing tomahawk, and felt the stroke, he could not see who sent it. Before such invisible foes the invaders soon had to retreat, going first south along the ridge to where it joins the main ridge which separates the French Broad from the Tuckasegee, and then turning with it to the northeast. As they retreated they tried to shield themselves behind rocks and trees, but the Nunne'hi arrows went around the rocks and killed them from the other side, and they could find no hiding place. All along the ridge they fell, until they reached the head of Tuckasegee not more than half a dozen were left alive, and in despair they sat down and cried out for mercy. Ever since then the Cherokee have called the place Dayulsun'yi, "Where they cried." Then the*

# NORTH CAROLINA RIVERS: FACTS, LEGENDS AND LORE

*Nunne'hi chief told them they had deserved their punishment for attacking a peaceful tribe, and he spared their lives and told them to go home and take the news to their people. This was the Indian custom, always to spare a few to carry back the news of defeat. They went home toward the north and the Nunne'hi went back to the mound.*

A few miles downstream from the Nikwasi Mound, another important Indian mound stands along the banks of the Little Tennessee. In a bend of the river near the mouth of Cowee Creek stands the Cowee Mound. Though not as widely known as the mound at Franklin, this mound stands in the heart of what was once the chief town of the Middle Cherokee settlements. Looking at the site today, it is hard to imagine a thriving Indian town here in such a rural place. But Cowee and its mound were once the center of a thriving settlement.

Like the Nikwasi Mound upstream in Franklin, the origin of the Cowee Mound is a mystery. The mound was built by the Mound Builders long before the Cherokee entered the region. The latter utilized the mound for over two hundred years.

In the spring of 1776, the naturalist William Bartram paid a visit to Cowee while out exploring the mountains inhabited by the Cherokee. He left the following description of Cowee and its ancient mound.

*The council or town-house is a large rotunda, capable of accommodating several hundred people; it stands on the top of an ancient artificial mount of earth, of about twenty feet perpendicular, and the rotunda on the top of it being above thirty feet more, gives the whole fabric an elevation of about sixty feet from the common surface of the ground. But it may be proper to observe, that this mount on which the rotunda stands, is of a much ancienter date than the building, and perhaps was raised for another purpose. The Cherokees themselves are as ignorant as we are, by what people or for what purpose these artificial hills were raised; they have various stories concerning them, the best of which amounts to no more than mere conjecture, and leave us entirely in the dark; but they have a tradition common with the other nations of Indians, that they found them in much the same condition as they now appear, when their forefathers arrived from the West and possessed themselves of the country, after vanquishing the nations of red men who then inhabited it, who themselves found these mounts when they took possession of the country, the former possessors delivering the same story concerning*

them: *perhaps they were designed and appropriated by the people who constructed them, to some religious purpose, as great altars and temples similar to the high places and sacred groves anciently amongst the Canaanites and other nations of Palestine and Judea.*

*The rotunda is constructed after the following manner, they first fix in the ground a circular range of posts or trunks of trees, about six feet high, at equal distances, which are notched at top, to receive into them, from one to another, a range of beams or wall plates; within this is another circular order of very large and strong pillars, above twelve feet high, notched in like manner at top, to receive another range of wall plates, and within this is yet another or third range of stronger and higher pillars, but fewer in number, and standing at a greater distance from each other; and lastly, in the centre stands a very strong pillar, which forms the pinnacle of the building, and to which the rafters centre at top; these rafters are strengthened and bound together by cross beams and laths, which sustain the roof or covering, which is a layer of bark neatly placed, and tight enough to exclude the rain, and sometimes they cast a thin superficies of earth over all. There is but one large door, which serves at the same time to admit light from without and the smoak to escape when a fire is kindled; but as there is but a small fire kept, sufficient to give light at night, and that fed with dry small sound wood divested of its bark, there is but little smoak; all around the inside of the building, betwixt the second range of pillars and the wall, is a range of cabins or sophas, consisting of two or three steps, one above or behind the other, in theatrical order, where the assembly sit or lean down; these sophas are covered with matts or carpets, very curiously made of thin splints of Ash or Oak, woven or platted together; near the great pillar in the centre the fire is kindled for light, near which the musicians seat themselves, and round about this the performers exhibit their dances and other shows at public festivals, which happen almost every night throughout the year.*

Cowee suffered greatly as a result of the military campaigns waged between the colonists and the Cherokee during the second half of the eighteenth century. During the American Revolution, the site was abandoned by the Cherokee as they sought refuge farther west.

The land on which the mound stands was owned by several individuals in the two centuries since the Cherokee abandoned the site. In 2006, the Little River Land Conservancy acquired ownership of the Cowee Mound. They in turn gave the land to the Cherokee. This site, which is on the National Register of Historic Places, might someday

# NORTH CAROLINA RIVERS: FACTS, LEGENDS AND LORE

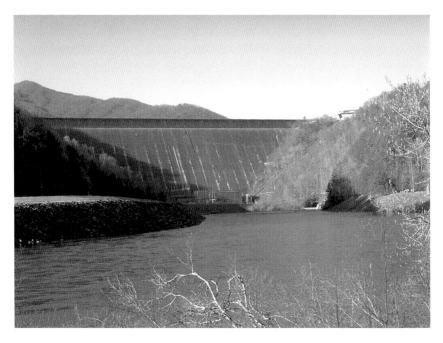

Fontana Dam was built across the Little Tennessee River by the TVA during World War II. The dam is 2,365 feet long and stands 480 feet high, creating a reservoir stretching 29 miles upstream. *Courtesy Tennessee Valley Authority.*

be the focal point of a historical park that tells the story of the glory days of old Cowee.

Downstream from Franklin, the waters of the Little Tennessee are impounded for the first of many times along its course, this time by Porter's Bend Dam, which creates Lake Emory, the drinking water supply for the town.

Beyond Porter's Bend, the river veers in a more northwesterly direction to its junction with the Nantahala, where this river bends to the north before bending back to the west near its junction with the Tuckasegee River.

The Little Tennessee continues on this course for several miles before reaching Fontana Dam. The water flows out of this lake and into Cheoah Lake, the backwaters of a dam on the Little Tennessee downstream from Fontana Dam. The Cheoah Hydroelectric Plant was built between 1916 and 1919. The dam, which stands 225 feet high, was reputed to have the highest overfall of any dam in the world back in the days when it was completed.

A mile below Cheoah Dam, which is just upstream from the mouth of Cheoah River, the Little Tennessee crosses the state line into Tennessee.

## Rivers of the Mississippi Watershed

Here, the river's waters are still inundated, this time as a result of Calderwood Dam. Fifty miles after crossing the state line, the Little Tennessee River joins the Tennessee River at Lenoir City, 601 miles above the spot where the latter river joins the Ohio at Paducah, Kentucky.

The Little Tennessee River drains 1,831 square miles of land in North Carolina. It descends over 1,000 feet as it flows across the state, covering 80 miles as it travels from the Georgia line to the Tennessee border.

The most imposing structure on the Little Tennessee River is Fontana Dam. The 480-foot-high concrete dam was completed in 1945. The massive structure was built by the Tennessee Valley Authority during World War II, and provides flood control, recreational opportunities and electrical power. The dam has the capacity to provide 225,000 kilowatts of electricity on a daily basis. The dam stretches 2,365 feet across the Little Tennessee River, and is utilized as a footbridge by the Appalachian Trail.

Fontana Lake, created by Fontana Dam, inundates several rivers and streams upstream of the dam. According to the TVA, the lake has 11,000 surface acres of water and 240 miles of shoreline.

Prior to the construction of Fontana Dam, this portion of the river was a remote place seldom visited by outsiders. In the 1890s, George Swain, J.A. Holmes and E.W. Myers examined several rivers of the state, including the Little Tennessee, for the North Carolina Geological Survey. In their report, they described the section now covered by the waters of Fontana and Cheoah Dams. "The first 4 miles of the river up from the Tennessee line lies in a deep, rocky gorge, through which it passes as a succession of rapids. The volume of water and the fall are ample for large possibilities in waterpower development, but the rocky walls of the stream are so steep and high, and the gorge so narrow, and the region so rugged as to be quite inaccessible."

The Little Tennessee was called Satiko River on early maps of the area. The river is also shown as a continuation of the Cherokee and Hogohege River, both early names for the Tennessee.

The Little Tennessee was accepted by many to be a continuation of the main stem of the Tennessee River, a fact that caused confusion in many sources. When Holmes and his companions were conducting their survey of the water power resources of the state in 1899, they referred to this river as the Tennessee River.

In 1889, the state legislature of Tennessee codified the course of the route of the Tennessee, which they stated began at "the junction of the north fork of the Holston River with the Holston, at Kingsport in Sullivan

# NORTH CAROLINA RIVERS: FACTS, LEGENDS AND LORE

County, Tenn., all usages to the contrary notwithstanding." The following year, the federal government officially established the junction of the Holston and French Broad as the beginning of the Tennessee River. Though it seems to have taken a few years to catch on, by the middle of the twentieth century the source of the river in the mountains of Georgia was accepted as the source of the river known as the Little Tennessee.

MIDDLE FORK FRENCH BROAD RIVER rises on the South Carolina border and flows in a northerly direction to its junction with the French Broad, two miles downstream from where the latter begins at the junction of the West Fork French Broad River and North Fork French Broad River at Rosman. This small watercourse was once known as Eastatoe Creek, as evidenced by the Price-Strother Map of 1808. The name Eastatoe is derived from the Cherokee word for the Carolina Parakeet, now extinct.

MIDDLE PRONG WEST FORK PIGEON RIVER rises near Parker Knob on the Blue Ridge Parkway and flows north between Fork Ridge on the east and Beartrap Knob, Beartrap Ridge, Little Beartail Ridge and Big Beartail Ridge on the west. It enters the West Fork Pigeon River near Burnett Siding.

MILLS RIVER begins at the junction of the North Fork Mills River and South Fork Mills River. It flows in an easterly direction for a short distance through a town of the same name and empties into the French Broad. Its short existence is confined to Henderson County.

The river was named in honor of William Mills, who was granted land along the river in 1787. Mills led an eventful life along the Carolina frontier. Born in 1746 in Virginia, he moved with his family to the Upcountry of South Carolina, where his mother was killed by Indians during the French and Indian War. His father, Ambrose, was a prominent Loyalist during the Revolutionary War who was captured at the Battle of Kings Mountain and subsequently hanged. William, who was also captured at Kings Mountain, would have shared his father's fate had not some of the Whigs who knew him intervened. After the war he settled in Cleveland County and became a noted explorer of the mountains of southwestern North Carolina.

NANTAHALA RIVER rises on the Blue Ridge near the Macon/Clay County line. It flows northwest between the Nantahala Mountains on the east and the Tusquittee Mountains, Valley Mountains, Snowbird Mountains

# RIVERS OF THE MISSISSIPPI WATERSHED

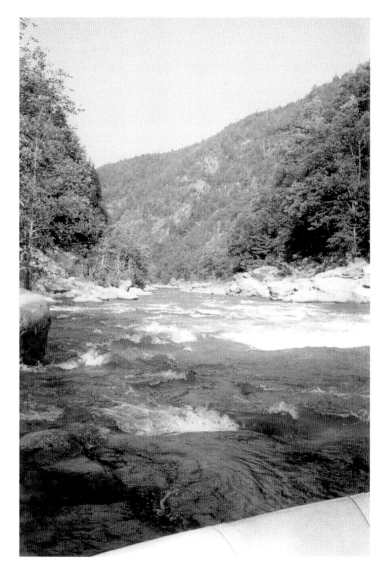

The Nolichucky River flows through the Nolichucky Gorge between Poplar, North Carolina, and Erwin, Tennessee.

and Cheoah Mountains on the west. This rugged valley is widely known as the Nantahala Gorge. It enters the Little Tennessee River at Almond.

The river's name is derived from the Cherokee word "Nundayeli," which Moody translated as "middle (i.e. noonday) sun." The term was

given to the gorge due to the fact that there are some remote places inside the steep walls of the canyon where the sun's rays generally do not shine directly on the river except in the middle of the day.

NOLICHUCKY RIVER begins where the Cane and Toe Rivers converge near the community of Huntdale, on the Mitchell and Yancey County border. The river then flows in a westerly course until it crosses through the Unaka Mountains and over the Tennessee line near Erwin, Tennessee. The river is 110 miles in length and flows into the French Broad River near White Pine, Tennessee.

As it exits North Carolina, the river flows through the Nolichucky Gorge, a haven for whitewater enthusiasts and the home of numerous whitewater outfitters. The difference between the river's surface and the mountains towering above is in many places over two thousand feet. Because of the rugged terrain, the gorge is accessible only by boat, railroad or foot. The rails of the Clinchfield Railroad, which followed the river through the Unakas as it traversed the Appalachians, connect the Midwest with the Southeast via rail.

From the junction of the Toe and Cane Rivers to State Line Rapids, the Nolichucky travels nine miles, descending 257 feet. The river continues in a northwesterly direction and emerges from the gorge at Erwin, Tennessee, four and a half miles downstream from the state line and 120 feet lower. From Erwin, the Nolichucky travels ninety-five miles to its junction with the French Broad.

The name Nolichucky is a Cherokee word that is reported to mean either "river of death" or "river of danger." Ramsey, in his book *Annals of Tennessee to the End of the Eighteenth Century*, notes that the original name for the river was "Nonachunkeh."

NORTH FORK FRENCH BROAD begins at the junction of Kiesee Creek and Courthouse Creek in the Pisgah Mountain Range, between Tanasee Ridge and Pilot Mountain. The river flows in a southerly direction until it unites with the West Fork French Broad River at Rosman to form the French Broad River, where the river's course takes a sharp turn to the northeast.

Courthouse Creek is believed by many to be the ultimate source of the French Broad River. This creek begins at the 5,462-foot-high peak known as Devil's Courthouse, the cave from which the mythical Cherokee figure Judaculla held his court and fomented evil against mankind.

Where this river has cut through Hayes Gap a deep, rugged gorge has been created, known as North Fork Gorge. The river drops up to 140 feet

## Rivers of the Mississippi Watershed

per mile in some sections of the gorge. In the 1920s an attempt was made to construct a railroad through this gorge. One of the first trains met with an accident and plunged into the river. The falls where this happened are to this day known as Boxcar Falls. There are several other picturesque falls on this stream, including French Broad, Mill, Elysian and Bird Rock Falls.

NORTH FORK MILLS RIVER begins at the junction of Big Creek and Fletcher Creek. It flows east/southeast to its junction with South Fork Mills River near Davis Mountain, where Mills River begins.

NORTH FORK SWANNANOA RIVER rises in Buncombe County in the Great Craggy Mountains on the south flank of Walker Knob Mountain near the Blue Ridge Parkway between the Great Craggy Mountains and the Black Mountain. It flows south to join Swannanoa River near Grovestone.

NORTH TOE RIVER rises from a spring on a high ridge 4,300 feet above sea level in Sugar Gap between Bald Mountain and Sugar Mountain in Avery County. It flows southwest approximately four miles, then turns west, flows through Newland and continues in a westerly direction approximately five miles to Minneapolis, sixty-four miles above the junction with Cane River. Here, the river veers south and travels in that general direction for thirteen miles, to the point where it flows between Gusher Knob and Burleson Bald. There, the river begins to wind and bend to the southwest, travels in that direction for five miles and bends back to the northeast at the base of Bent Ridge Knob at a place known as the Lower Bend. The river continues in that direction approximately two miles, then bends back to a more southerly direction until crossing from Avery into Mitchell County and turning west. Eight miles downstream, the river makes its through Spruce Pine and continues in a westerly direction toward Penland, home of the Penland Arts Center, which specializes in the perpetuation of Appalachian folk art.

The last wild elk ever seen in North Carolina was killed along the North Toe River circa 1800. Colonel William Davenport, whose father Martin settled near the river at the end of the Revolutionary War, shot the animal while on a hunting trip near his father's house. Davenport eventually settled in Caldwell County, where he was prominent in the affairs of his community. He served as the surveyor representing North Carolina when the state's western boundary was run in 1821.

# NORTH CAROLINA RIVERS: FACTS, LEGENDS AND LORE

The Oconaluftee River inside the Great Smoky Mountains National Park.

NOTTELY RIVER rises on the Blue Ridge in northern Georgia between Turkeypen Mountain and Horsetrough Mountain. It flows basically northwest, passing on the southwest side of Blairsville. Much of the river between Georgia 325 and U.S. 76 is under the water of Nottelly Lake, created by a TVA dam across the river near the community of Ivy Log.

# Rivers of the Mississippi Watershed

From the dam the river flows north across the North Carolina/Georgia line, then makes a bend to the west and then back northeast near the town of Ranger. It continues this track northeast through the gorge between Halls Knob and Wildcat Mountain and enters the Hiwassee River west of Murphy. From its mouth upstream to near Ranger the Nottely's waters are inundated by the backwash from Hiwassee River.

Oconaluftee River begins at the confluence of Beech Flats Prong and Kephart Prong in the Great Smoky Mountains National Park. It flows parallel to U.S. 441 and crosses into the Cherokee Reservation near the Blue Ridge Parkway. The river flows south by the town of Cherokee and then turns west/southwest and parallels U.S. 19. It enters the Tuckasegee River near the community of Ela.

According to Moody, the Oconaluftee gets its name from a Cherokee word, "Egwanulti." This is translated as "by the river."

Pigeon River begins at the confluence of the West Fork Pigeon River and East Fork Pigeon River at the community of Silver Bluff in Haywood County. It flows north for approximately five miles and reaches the town of Canton. A mile north of the town bridge, the Pigeon River makes a turn to the west and flows in that direction toward Clyde, where the river bends back toward the north. When the river reaches Jonathans Creek, it curves to the northeast and back to the north as it flows through White Oak Gorge. At the northern end of this gorge, the Pigeon flows under I-40 bridge and enters the waters of Walters Lake, created by Walters Dam, five miles downstream at the mouth of Cataloochee Creek. The Walters Hydroelectric Plant was completed in 1930 by CP & L. The company dug a tunnel connecting the lake with the power station a dozen miles downstream. One section of the 14-foot-wide tunnel cuts through a six-mile section of solid bedrock. When it was completed, the Waterville Hydroelectric Station had the distinction of having the highest head (863 feet) of any dam in the Eastern United States.

Pigeon River continues in a northerly direction until it reaches Big Bend, between Buzzard Roost and Hickory Ridge. Here, the river makes a sharp bend to the west for two miles, then back to the northwest and across the state line into Tennessee, three miles downstream from the mouth of Big Creek.

After crossing the state line, the river flows twenty-six miles farther in a northeasterly direction to its junction with the French Broad near Newport, Tennessee.

# NORTH CAROLINA RIVERS: FACTS, LEGENDS AND LORE

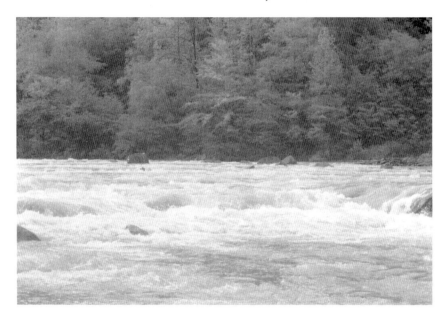

The Pigeon River in Haywood County.

Pigeon River loses over 1,200 feet in elevation between Canton and the Tennessee border. The drainage basin of the Pigeon River in North Carolina is 572 square miles.

RAVEN FORK RIVER begins at the confluence of Left Fork Raven Fork River and Right Fork Raven Fork River between Hyatt Ridge and Bulldie Ridge in the Great Smoky Mountains. It meanders south and is joined by Straight Fork River in the Cherokee Indian Reservation. The Raven Fork then continues south to its junction with the Occonaluftee River.

RIGHT FORK DAVIDSON RIVER rises on Fork River Ridge and flows southeast to its junction with Cove Creek to form Davidson River.

RIGHT FORK RAVEN FORK RIVER rises on the south flank of Mount Hardison and flows south then west to its junction with the Left Fork Raven Fork River.

RIGHT FORK SWANNANOA RIVER rises in Buncombe County on the flanks of Potato Knob in the Black Mountains. It flows in a southwesterly direction to its junction with the North Fork Swannanoa River, between Little Craggy Knob and Graybeard Mountain.

## Rivers of the Mississippi Watershed

Right Hand Prong West Fork Pigeon River rises on the flank of Richland Balsam and flows east into Middle Prong West Fork Pigeon River.

Right Prong South Toe River begins at five thousand feet above sea level on Potato Knob and flows east for about three miles before it joins the Left Prong of South Toe River. In that short distance the river descends almost two thousand feet.

South Fork Mills River rises near Wagon Road Gap in Transylvania County. It flows southeast near McCall Mountain and then travels northeast along the flank of Forge Mountain in Henderson County to its junction with North Fork Mills River.

South Prong Little River rises in Transylvania County near Happy Acres south of Brevard. It flows north to its confluence with Little River at Dehon Mountain.

South Toe River begins at the confluence of the Left and Right Prongs of South Toe River on the eastern flank of the Black Mountains. The Black range includes Mount Mitchell, the highest peak east of the Mississippi at 6,684 feet above sea level. The Black Mountains are so named because of the dark appearance that the evergreen forests have given these majestic peaks.

The South Toe flows over numerous cascades as it flows through the Black Mountains. The highly popular U.S. Forest Service campground Carolina Hemlocks sits astride this river, which is utilized by swimmers, canoeists and fishermen.

There are numerous mica mines near the river that silt up the river and give it a gray hue.

The South Toe flows in a northerly direction until it unites with the North Toe near Kona.

Straight Fork River rises between Mount Hardison and Luftee Knob and flows south/southwest by Hyatt Ridge into the Cherokee Reservation. It joins the Raven Fork River in Big Cove.

Swannanoa River rises in Swanannoa Gap in the Blue Ridge in Buncombe County. It flows west through Black Mountain and joins the French Broad at Asheville. The river is roughly twenty-five miles in

length, and flows by such prominent landmarks as Montreat College and the Biltmore Estate.

Mooney wrote that the name Swannanoa was the corruption of a Cherokee phrase describing a trail that led east across the mountains toward the territory occupied by the Cheraw. "The name of the stream and gap is a corruption of the Cherokee Suwali-Nunna hi, 'Suwa'li Trail.'"

TELLICO RIVER rises in Cherokee County in Cold Spring Gap just north of McDaniel Bald near where the Beaver Dam Mountains and the Snowbird Mountains come together. It flows west for approximately five miles before passing by State Line Ridge and Jenks Knob as it crosses into Tennessee. It then flows over fifty miles through the mountains of North Carolina and Tennessee before its junction with the Little Tennessee River at Venore, Tennessee. The lower reaches of the river are impounded by the Tellico Dam, which was built by the TVA across the Little Tennessee near the Tellico's mouth.

According to Moody, the meaning of the name has been lost, but it comes from the Cherokee word "Talikwa," a name given to several Cherokee settlements, including Great Tellico, which was located on this river at what is now called Tellico Plains, Tennessee. When William DeBry drew his map of Fort Loudoun in 1773, he labeled this watercourse "Talequo River."

TOE RIVER begins at the confluence of the North and South Toe Rivers near Kona. It flows in a northwesterly direction until it unites with the Cane River, where the Nolichucky officially begins. In its twenty-one-mile course, the Toe River drops 307 feet in elevation.

A colorful legend surrounds the name of this stream. Supposedly there was once an Indian maiden named Estatoe who was in love with a brave from another tribe. When the brave came to claim his would-be bride, her people slew him. Devastated, Estatoe threw herself into the river, where she drowned. From then on, the Indians called this river the Estatoe in her honor. When the Europeans arrived they shortened the name to just plain Toe, which is still in use today.

The Toe River and its valley was one of the many avenues opening the remote region it drains. The Clinchfield Railroad followed the course of the Toe and Nolichucky into the mountains and provided the valley with communication with the outside world.

# Rivers of the Mississippi Watershed

Tuckasegee River begins at the junction of Panthertown Creek and Greenland Creek at the base of Little Green Mountain in Jackson County. From there, the river winds across some of the highest and most rugged terrain in the South, emptying into the Little Tennessee River over seventy river miles away to the west.

Most of the wilderness along the headwaters is preserved thanks to the work of the Nature Conservancy, which purchased several thousand acres of land from the Mead Corporation in 1981 for $13.4 million. The group then turned the land over to the U.S. Forest Service, which added it to the Nantahala National Forest.

One spot along the upper reaches of the river that stands out for its scenic beauty is Bonas' Defeat, a gorge where the Tuckasegee rushes across numerous rock outcroppings. The water has worn some interesting patterns in the rock. The unusual name is derived from a hunting dog named Bonas, who fell to his death from the rocky cliff while in pursuit of a deer.

Twenty miles downstream from Bonas' Defeat, the Tuckasegee flows under Dick's Gap Bridge and passes along the eastern side of Cullowhee. This town gets its name from a Cherokee word meaning "place of the lilies." Western Carolina University is located in Cullowhee.

Just downstream from the bridge at Dillsboro, travelers on the river will notice a wrecked train on the right bank of the river. This was the spot where a famous train wreck scene in the 1993 film *The Fugitive* was shot. Legend has it that the section of the river just downstream from the wreck is haunted by the ghosts of a party of hapless convicts who drowned in the river during the construction of the railroad tunnel that pierced the ridge on the left bank of the river.

Nearly a dozen miles downstream from the train wreck, the Oconaluftee River flows into the Tuckasegee from the right.

Twelve miles downstream from Bryson City, the Tuckasegee flows into the Little Tennessee River. Today, this spot where the rivers meet is under the backwaters of Fontana Lake, fifteen miles upstream from Fontana Dam.

The river takes its name from the Cherokee town once located along its banks.

Valley River rises in the Snowbird Mountains near the boundary between Graham and Cherokee Counties and flows southeast for approximately one mile before turning toward the southwest near Red Marble Gap. The river follows a southwesterly course across Cherokee

# NORTH CAROLINA RIVERS: FACTS, LEGENDS AND LORE

County, flowing through Andrews on its way to its junction with the Hiwassee River at Murphy.

The Valley River is so named because it flows through an open, wide valley in the midst of numerous high mountains. The river flows between the Valley River Mountains to the south and east and the Snowbird Mountains to the north and west.

There is an interesting legend concerning a mythical creature that the Cherokee Indians believed inhabited a rock at the point where Valley River flows into the Hiwassee. The spot is now covered in the backwaters of the Hiwassee Reservoir. At the mouth of the Valley River there was a rock ledge that stretched nearly across the river. The Indians utilized this ledge as a convenient crossing spot. They called the place Tlanusiyi, or "the leech place." According to legend, there was a particularly aggressive giant red and white leech that inhabited a deep pool near the crossing. On occasions, this creature jumped out of the water and killed hapless Indians who crossed on the ledge.

The Indians eventually grew so wary of this beast that they avoided crossing the river on the ledge if at all possible. They also maintained that there was an underground cavern connecting Valley River with the nearby Nottely River, and that the giant leech would sometimes visit the Nottely. There have been no reports of individuals being devoured by giant leeches in the area since the late 1700s.

WATAUGA RIVER rises on the northeast side of Linville Gap and flows along the northeast side of Grandfather Mountain and through the town of Foscoe. It turns northwest and flows into Watauga Gorge and beyond to Tennessee, where its waters are impounded by Lake Watauga. The Watauga eventually flows into the Holston River.

Though not as famous as Linville or Nantahala Gorges, Watauga Gorge is a place that is both rugged and beautiful. Its waters should not be attempted by novice canoeists, as the numerous large boulders present in the stream can pose a challenge to even the most experienced paddlers. Those who do visit the gorge are rewarded with some beautiful river scenery and can explore such rapids as Stateline Falls or the Anaconda. The Watauga River drops over six hundred feet in elevation over the fourteen-mile section between the mouth of Crab Orchard Creek and the Tennessee line.

During its northwestern run, the Watauga flows through the town of Valle Crucis, which takes its name from a mission established nearby in 1844 by Bishop Levi Ives of the Episcopal Diocese of North Carolina.

# Rivers of the Mississippi Watershed

Ives was impressed with the place because of its natural beauty, and because three creeks—Clarks Creek, Dutchman's Creek and Crab Orchard Creek—flow together in the valley and form the pattern of a cross. Thus he named his mission Valle Crucis. The town of Valle Crucis is seventy miles upstream from the mouth of the Watauga River.

The origin of the name Watauga is uncertain, though the most popular account states that it was derived from a Cherokee word that meant "beautiful waters."

WEST FORK FRENCH BROAD RIVER rises between Shelton Pisgah Mountain and Owens Gap. It flows east around the base of Big Pisgah Mountain, then veers southeast. As it passes Quebec Mountain the river turns to the northeast and unites with the North Fork French Broad River to form the French Broad River at Rosman.

WEST FORK PIGEON RIVER rises near Mount Hardy on the Blue Ridge Parkway and flows north between Green Knob and Sam Knob, then bends northwest and flows by Birdstand Mountain before bending back to the north at its confluence with Middle Prong. The river continues north to its confluence with East Fork Pigeon River at Silver Bluff.

WEST FORK TUCKASEGEE RIVER begins in Hurricane Lake on the Blue Ridge and flows north. Its waters are backed up by Thorpe Dam at Onion Falls to form Thorpe Reservoir, nearly 1,500 acres and 4,000 feet above sea level. The West Fork flows out of the reservoir north through a gorge between Cullowhee Mountain and the Blue Ridge to unite with Tuckasegee River near the community of Tuckasegee. The distance from Thorpe Dam to the confluence with the Tuckasegee River is 9.5 miles.

YELLOWSTONE PRONG rises on the slopes of the Balsam Mountains and flows in a northeasterly direction before joining Dark Prong to form East Fork of Pigeon River. The Yellowstone flows through some very rugged terrain and over picturesque waterfalls in its mad dash down the mountainside. Hiking trails along the Blue Ridge Parkway and the Shining Rock Wilderness Area provide access to this remote yet beautiful area.

The most visited spots on the Yellowstone are its three major falls—Upper Falls, Second Falls and Yellowstone Falls. Farther downstream the river flows through a cleft in the side of a mountain that forms a powerful chute of water above which a walkway along a hiking trail passes.

# NORTH CAROLINA RIVERS: FACTS, LEGENDS AND LORE

Another spot that the Yellowstone passes is known as Graveyard Fields. This high mountain meadow derives its name from the numerous dead tree trunks that are scattered about the mountainside and resemble tombstones from a distance. The trees were originally killed when a fire destroyed over 25,000 acres in the area in 1925.

According to Powell, the Yellowstone gets its name "because of the yellow color of mosses growing on stones in the stream." Another popular belief, though probably just a myth, is that the name comes from gold nuggets that can be found by a lucky prospector.

---

The following rivers reach the Ohio River via the Kanawha River. The Kanawha, which begins at the confluence of the New and Gauley Rivers at Gauley Bridge, West Virginia, drains nearly 12,235 square miles of land in West Virginia, Virginia and North Carolina.

EAST FORK OF SOUTH FORK NEW RIVER rises near Bamboo in Watauga County and flows west through Happy Valley approximately five miles to its junction with the Middle Fork of the South Fork New River to form the South Fork of New River.

FLANNERY FORK flows out of Trout Lake at Moses Cone Memorial Park on the Blue Ridge Parkway. It flows north to near Boone, where it unites with East Fork and Middle Fork to form South Fork New River.

LITTLE RIVER (NEW) rises near Piney Fork Church in Alleghany County and flows northeast by the town of Sparta. Near the Virginia line, it bends northwest to enter the New River near the town of Independence, Virginia.

MIDDLE FORK OF SOUTH FORK NEW RIVER flows out of Bass Lake at Blowing Rock in Watauga County. It flows east into Chetola Lake, then travels in a northerly direction for about ten miles to its junction with the East Fork of South Fork New River to form the South Fork New River. The river flows by Tweetsie Railroad as it travels between Boone and Blowing Rock.

# RIVERS OF THE MISSISSIPPI WATERSHED

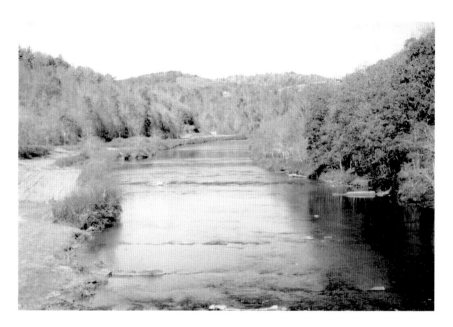

The New River flows north, and is a tributary of the Ohio River. *Courtesy of Joey Powell.*

NEW RIVER begins at the junction of the North Fork New River and South Fork New River on the Ashe/Allegheny line. The New flows north/northwest for nearly 260 miles through North Carolina, Virginia and West Virginia. It joins the Gauley River at Gauley Bridge, West Virginia, to form the Kanawha River. The waters of the Kanawha flow into the Ohio, the Mississippi and eventually the Gulf of Mexico.

Many believe the New River is actually the oldest river in North America, at least in a geological sense. It is reportedly second in age only to the more famous Nile River in Africa. As the theory goes, the New existed long before the Appalachians were uplifted and was thus able to maintain its northerly course.

Others maintain that the New shares another interesting characteristic with the Nile. Both, of course, flow north. Though it is rare for a large river to flow north, it is not altogether unknown, even here in America. Two large rivers that flow in a northerly direction include the Saint Johns River in Florida and the MacKenzie River in Canada.

# NORTH CAROLINA RIVERS: FACTS, LEGENDS AND LORE

NORTH FORK NEW RIVER rises in Pottertown Gap between Snake Mountain and Elk Knob in Watauga County and meanders north/northeast through western Ashe County to its junction with South Fork New River along the Ashe/Alleghany border to form the New. For the most part this shallow stream is characterized by small shoals and rapids through its length.

SOUTH FORK NEW RIVER begins near Blowing Rock and the Blue Ridge Parkway at the confluence of the Flannery Fork, Middle Fork and East Fork of New River. It winds its way north to the junction with the North Fork of New River, where the New River officially begins. Many access points for the New River State Park are located along the South Fork of New River.

## Chapter 4

# The Pee Dee

Although the streams in this section flow through virtually every part of the state, their waters eventually reach the Atlantic Ocean via Winyah Bay near Georgetown, South Carolina. The Pee Dee River Basin is North Carolina's second largest river basin, containing 7,213 square miles of land. According to the U.S. Geological Survey, there are 5,991 miles of rivers and streams within North Carolina's portion of the Pee Dee Basin. The rivers in this system drain a wide variety of landforms. Even though North Carolina's portion of the basin is for the most part located within the Piedmont region, streams in the basin drain landforms as diverse as the high mountain peaks of the Blue Ridge to the mysterious Carolina bays of the southeastern part of the state.

ARARAT RIVER rises between Groundhog Mountain and Pinnacles of Dan in southwestern Virginia. It flows southwest across Patrick County and crosses the North Carolina line into Surry County. The river runs east of the town of Mount Airy, and after its junction with Caudle Creek south of town meanders south/southeast by Pilot Mountain to its junction with the Yadkin River near Siloam.

The river takes its name from the Biblical Mount Ararat, the place where Noah's Ark came to rest following the deluge. The name was once applied to Pilot Mountain, as is shown on Henry Mouzon's map, drawn in 1775.

# NORTH CAROLINA RIVERS: FACTS, LEGENDS AND LORE

BIG SWAMP RIVER begins at the junction of Big Marsh Swamp and Galberry Swamp in Robeson County near Tolarsville. It meanders in a southerly direction to its junction with Lumber River near Boardman at a place called "the Net Hole." The mouth of the Big Swampy River is just over a mile upstream from where U.S. 74 crosses Lumber River.

EAST PRONG LITTLE YADKIN RIVER rises on the east of Moore's Knob and flows nearly ten miles southwest to its junction with the West Prong Little Yadkin River to form Little Yadkin River.

EAST PRONG LOWER LITTLE RIVER rises on Moore Mountain in Alexander County and flows southeast then bends southwest. It passes between Love Mountain and Davis Mountain and enters Lower Little River northwest of Taylorsville.

EAST PRONG ROARING RIVER begins at the confluence of Stone Mountain Creek and Bullhead Creek inside the bounds of Stone Mountain State Park. The river traverses the park as it flows in a southerly direction to its confluence with Middle Prong Roaring River, where Roaring River officially begins.

ELKIN RIVER rises in the mountains near Doughton and flows southeast to join the Yadkin River at the town of Elkin. The region through which it flows is known for its apple production, as there are numerous thermal belts in these mountains that protect the trees from frost.

One legend about how this river got its name states that an Indian was chasing an elk that fell into the river, at which time the Indian shouted "elk in!" to his fellow hunters.

FISHER RIVER rises to the west of Fisher Peak on the North Carolina/Virginia border, flows southeast through Surry County by Buck Mountain and turns east near Blevins Store. A short distance after its junction with Little Fisher River near Dobson it bends south and continues in that general direction to its junction with the Yadkin between Elkin and Rockford.

Fisher River was originally known as Fish River. The river took its name from an early settler, William Fish, who lived near the mouth of the river in the mid-1700s. In March of 1756, Fish was killed by Little Carpenter and a war party of Cherokee who were raiding through the settlements in the upper Yadkin River Valley.

# The Pee Dee

The river eventually became Fish's River and Fishes River, which evolved into Fisher River. This name has been firmly established since the early 1800s. Some maintain that the river takes its name from Colonel Daniel Fisher, the man for whom Fisher Peak is named. Colonel Fisher was a member of the party surveying the North Carolina/Virginia border in this area, and supposedly died while running the line across the peak that now bears his name. Colonel Fisher is reputed to be buried on Fisher Peak. However, the name Fish River predates Fisher's visit to the area.

LITTLE FISHER RIVER rises on Fisher Peak near the North Carolina/Virginia line and flows southwest through Surry County to its junction with Fisher River four miles northeast of Dobson.

LITTLE PEE DEE RIVER begins in southeastern Scotland County at the junction of Bridge Creek and Leith Creek. It flows across the southwest corner of Robeson County and continues southeast to its junction with the Pee Dee River near Marion, South Carolina.

According to some sources, however, the Little Pee Dee River does not begin in Scotland County, but begins at Red Bluff in Marlboro, South Carolina.

The Little Pee Dee River drains 3,022 square miles of land, of which 1,942 square miles are in North Carolina.

LITTLE RIVER rises near Asheboro and flows south through the Uwharrie Mountains and the Sandhills. It empties into the Pee Dee River in Richmond County. The river flows past the Town Creek Indian Mound. A state historic site is located there to describe the life of the aboriginals who constructed the mound.

LITTLE UWHARRIE RIVER rises southwest of Archdale and flows southwest for about five miles then turns east to unite with the Uwharrie near Shepherd Mountain in western Randolph. This waterway is popular with local fishermen.

LITTLE YADKIN RIVER begins at the junction of West Prong Little Yadkin River and East Prong Little Yadkin River. It meanders across southwest Stokes County and extreme northwest Forsyth County before joining the Yadkin River in Surry County. The drainage basin of this river is fifty-eight square miles.

# NORTH CAROLINA RIVERS: FACTS, LEGENDS AND LORE

The Little Uwharrie River flows through the rugged terrain of the Uwharrie Mountains before joining the Uwharrie River west of Asheboro.

LUMBER RIVER is a black water river that drains the Sandhills region of North Carolina. The river begins where Drowning Creek and Buffalo Creek unite in Scotland County. It joins the Little Pee Dee River near Nichols, South Carolina. The total distance traveled by the river is 150 miles, of which 115 miles are in North Carolina.

Lumber River takes its name from the vast timber resources found along it banks. Early settlers relied upon these commodities of the forest to make a living.

The Lumber River is the only river in the eastern part of North Carolina to be designated a National Wild and Scenic River. Lumber River State Park, established in 1989, contains over seven thousand acres of land scattered along several points of the river. Park headquarters are currently located at the Princess Anne Access Area.

LYNCHES RIVER rises in southern Union County south of Monroe and flows south into South Carolina. It meanders southeast and joins the Pee Dee near Johnsonville. This river drains over 881,202 acres of land, most of which are in South Carolina.

# The Pee Dee

Middle Fork Reddies River begins at the confluence of Roten Creek and Bowlin Creek in Wilkes County. It flows southeast to its junction with South Fork Reddies River near Rendezvous Mountain.

Middle Prong of Roaring River is formed in Wilkes County near Stone Mountain State Park by the junction of Basin and Lovelace Creeks. It flows south between Greenstreets and Carter's Mountain to its junction with East Prong Roaring River where Roaring River begins.

Mitchell River rises north of Roaring Gap and flows east. It turns south/southeast near Potters Creek and flows into the Yadkin near the Elkin Airport and the community of Burch. This river drains eighty-one square miles of land.

North Fork Reddies River rises near the Ashe/Allegheny/Wilkes border and flows south to its junction with South Fork Reddies River where the Reddies River begins.

North Prong South Fork Mitchell River rises near Roaring Gap and flows southeast into the South Fork Mitchell River.

Pee Dee River begins at the junction of Yadkin River and the Uwharrie River, along the Stanley and Montgomery County line in the Uwharrie Mountains of central North Carolina between Albemarle and Troy. The river's waters are here a part of Lake Tillery, which is formed by a dam that was built across the Pee Dee River between Norwood and Mount Gillead in 1928. The lake contains 5,260 acres.

Downstream from the Lake Tillery, the waters of the Pee Dee flow south, with Rocky River joining on its western shore. This important spot was once considered the official beginning of the Pee Dee, and the portion of the river upstream was the Yadkin. Colson's Ferry, located across the Pee Dee River at the mouth of Rocky River, was an important crossing of the Pee Dee during the Revolutionary War.

At Ansonville, the Pee Dee makes a bend to the east and flows through the Pee Dee National Wildlife Refuge. The 8,443-acre reserve was established here in March of 1963. The primary purpose of the refuge is to serve as a habitat for migratory songbirds and waterfowl. More than 180 species of birds have been found here, including endangered red-cockaded woodpeckers, wild turkeys and bald eagles.

# NORTH CAROLINA RIVERS: FACTS, LEGENDS AND LORE

The Lumber River flows by a bluff known as the Chalk Banks near Wagram. This area is part of the Lumber River State Park.

The river continues in an easterly direction for eight miles, then takes a turn to the south and passes the mouth of Little River, which flows in from the north. A couple of miles downstream, the river flows through an area characterized by high steep banks and rugged terrain. And were it not for the fact that the backwaters of Blewett Falls Dam now create a large lake, this would be an area of the river filled with

# The Pee Dee

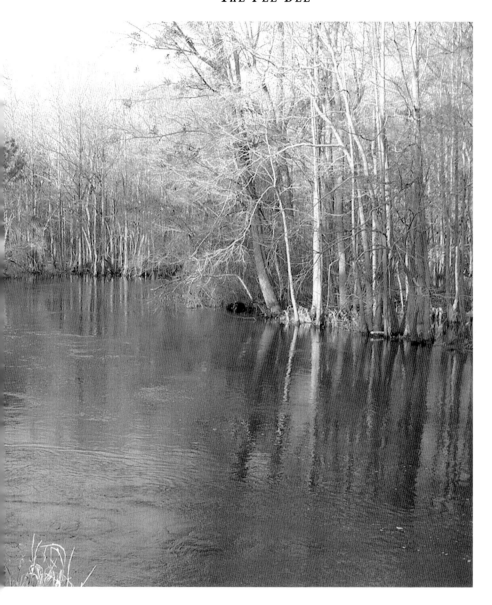

several shoals and rapids as it passes through the Grassy Islands. Grassy Island Ford, an important crossing point along the Pee Dee where several Indian trails converged, crossed the river here.

Blewett Falls Dam was constructed across the Pee Dee in 1926. The dam stretches 1,470 feet across the river. Downstream from the dam, the Pee Dee River flows unimpeded south to Winyah Bay. On the western

The bridges spanning the Pee Dee River near Rockingham.

bank of the river, downstream from the U.S. 74 bridge, stood the old town of Sneedsboro, founded at what was hoped would be the head of navigation on the river in 1795.

A dozen miles downstream from the Blewett Falls Dam, almost immediately after passing Whortleberry Creek, the Pee Dee crosses the state line into South Carolina. The river passes several interesting locales in South Carolina on its journey to the sea, including the town of Cheraw. The river enters Winyah Bay at Georgetown.

The Pee Dee River takes its name from the Pee Dee Indians, a tribe that was living along the banks of this river when the first European settlers arrived. The Pee Dee were responsible for building the Town Creek Indian Mound on the banks of Little River in Montgomery County. The Pee Dee were officially recognized as an Indian tribe by the state of South Carolina in the early twenty-first century. The name was originally written as one word—Peedee—and this spelling was in use in South Carolina into the early nineteenth century. In South Carolina, the river is often referred to as the Great Pee Dee River.

REDDIES RIVER begins at the confluence of the North Fork Reddies River and the South Fork Reddies River near Rendezvous Mountain. It flows southeast and enters Yadkin River at North Wilkesboro.

Reddies River was the site of the longest log flume ever built in North Carolina. The Giant Lumber Company, which built the flume, was officially organized on April 13, 1907, by John Matthias Bernhardt, E.P. Wharton, W.J. Palmer and F.G. Harper. Bernhardt was the founder of the Bernhardt Furniture Company and was involved in many timber companies and lumber operations in the mountains of Virginia and North Carolina. This particular company spent two years building a flume that stretched nineteen miles across Wilkes County from their lumberyard along the Southern Railway at North Wilkesboro to the company's vast timber properties on the flanks of the Blue Ridge.

The route of the flume was laid out by W.J. Palmer, who was very meticulous in choosing the exact path the flume should take. Under ideal conditions, the company would have utilized the river to transport the logs down out of the mountains, but the area's terrain made this impractical because Reddies River was in many places too steep and contained too many rocks and rapids. So Palmer laid out the route for his flume alongside Reddies River, utilizing the stream's water to move the logs along on the steadier grade of the flume.

# THE PEE DEE

A log flume was constructed alongside Reddies River in Wilkes County to transport logs through the mountainous terrain along the Blue Ridge during the early twentieth century. *Courtesy of James Larkin Pearson Library, Wilkes Community College, Wilkesboro, North Carolina.*

Palmer and his associates employed several ingenious methods to negotiate this rugged terrain, which included digging cuts through ridges and traversing valleys with aqueducts that reached forty feet above the surface below. The flume resembled a railroad trestle as it snaked its way down Reddies River, across Wilkes County and up into the high mountains.

When constructing their flume, the company incorporated two types of flume designs into their structure. In the upper reaches, they utilized the European rectangular style of flume, but farther downstream they switched to the V-shaped flume. This was done to alleviate some of the pressure of the logs backed up in the flume as they made their way to the end of the run.

The Giant Lumber Company's flume began operating in 1909. On an average day, logs put into the flume could make the nineteen-mile trip from

the Blue Ridge to North Wilkesboro in about six hours. During its peak operation, the flume transported 100,000 feet of lumber per day. In addition to the logs, bark to be used for tanning was also sent down the flume.

A writer for the *Wilkes Patriot* witnessed the flume in operation and described how logs and bark were transported.

> *In sending the lumber down the flume one plank is tacked behind another, making strings of about 500 feet, following close together. In this way the capacity of the flume is about 100,000 feet daily (or about four car loads). Sometimes the lumber is bundled, a string tied around each end of about 100 feet and tan bark bundled and laid on top. In this way as large an amount of lumber and 50,000 pounds of tan bark in a day can be handled, the bark being kept dry.*

The flume stood along the Reddies River for only seven years. In June of 1916, catastrophic floods resulting from a hurricane inundated western North Carolina. Among the numerous structures destroyed by the floodwaters was the Giant Lumber Company's flume, which washed out at several places during the torrential rains. After this natural disaster, the flume was never rebuilt.

ROARING RIVER was formed by the junction of East Prong Roaring River and the Middle Prong Roaring River south of Carter's Mountain in central Wilkes County. It flows generally east to its junction with the East Prong Roaring River, then heads southeast to its junction with the Yadkin River near the town of Roaring River.

According to Powell's *Gazetteer*, this river received its name due to an early account that claimed the river came "'rushing and roaring' out of the Blue Ridge Mountains."

ROCKY RIVER rises in Mooresville and flows south. It meanders southeast between Charlotte and Concord. At Georgeville, the river makes an abrupt turn to the southwest and meanders in a southerly direction past Midlands. At the spot where the county lines of Union, Stanly and Cabarrus intersect, the Rocky bends to the east and flows in an easterly, sometimes northeasterly, direction until its confluence with Big Bear Creek near Aquadale, at which point Rocky River makes another abrupt turn to the south. At Richardson Creek, the river resumes its eastward movement, flowing past Buzzard Island, and joins the Pee Dee River

# The Pee Dee

The Rocky River flows by the Reed Gold Mine in Cabarrus County.

at the spot where Anson, Montgomery, Stanly and Richmond Counties unite between Mount Gilead and Ansonville.

The mouth of the Rocky River was once accepted as the beginning of the Pee Dee River instead of the mouth of Uwharrie River, farther upstream.

This river drains 1,405 square miles of land. All of this land is in the Piedmont region of North Carolina.

The Rocky River flows through the heart of North Carolina's gold-producing region. Conrad Reed is credited with discovering gold in Little Meadow Creek, a tributary of Rocky River, in 1799. The Reed Gold Mine was located on the ridge separating the river from Little Meadow Creek, and is now the site of the Reed Gold Mine State Historic Site.

SOUTH FORK MITCHELL RIVER rises near Roaring Gap and meanders southeast across western Surry County. It unites with Mitchell River northeast of Elkin.

# NORTH CAROLINA RIVERS: FACTS, LEGENDS AND LORE

Coolemee was once the site of an important textile factory that was built along the South Yadkin River.

SOUTH FORK REDDIES RIVER rises near Gillam Gap and flows southeast by Judd Mountain and Rendezvous Mountain to its confluence with North Fork Reddies River.

SOUTH PRONG LITTLE RIVER rises in southern Randolph County and flows northeast by Cedar Rock Mountain, then bends southeast and flows into Little River near Kiss Mountain.

SOUTH PRONG WEST BRANCH ROCKY RIVER rises at Davidson in Mecklenburg County and flows southeast into the West Branch of Rocky River.

SOUTH YADKIN RIVER rises between Little Mountain and Pores Knob in the Brushy Mountains in Wilkes County. It flows southeast into Alexander County, bends to the east near Hiddenite and flows across Iredell County. It forms the Davie/Rowan border, then veers southeast past Cooleemee. The river enters the Yadkin north of Salisbury at a place known as the "Forks of the Yadkin." The town of Clinton, long since abandoned, was located at the Forks.

This river drains 820 square miles of land.

# THE PEE DEE

The Uwharrie River flows through the Uwharrie Mountains, a range of extinct volcanoes in central North Carolina. The river was once dredged extensively in the search for gold.

UWHARRIE RIVER rises near the town of Archdale in northwestern Randolph County and flows southeast about sixty miles through the Uwharrie Mountains. It unites with the Yadkin in Montgomery County west of Troy to form the Pee Dee River.

Throughout this course, the Uwharrie contains numerous Class I and Class II rapids and is therefore popular with canoeists. The stream drops over seven hundred feet in elevation from source to mouth, making it a fast-paced stream.

The Uwharrie Mountains, through which the river runs, are the remains of an ancient mountain range. These extinct volcanoes are said by geologists to have been higher than the Alps, yet today they have been eroded until the highest peak is now about 1,005 feet above sea level.

The origin of the name Uwharrie is uncertain. When John Lawson crossed the river on his journey of exploration in 1701 he called it "Heighwaree." The name is also spelt "Uharrie" in some records, but Uwharrie seems to be the most popular version. Just what this word meant is uncertain.

# NORTH CAROLINA RIVERS: FACTS, LEGENDS AND LORE

The Waccamaw River flows out of Lake Waccamaw, the largest of the Carolina bays.

WACCAMAW RIVER flows south out of Lake Waccamaw in Columbus County. Though Lake Waccamaw is approximately 5 miles from the Cape Fear River, the Waccamaw River drains south and enters Pee Dee River over 120 miles away, as the proverbial crow flies, at Georgetown, South Carolina. The Waccamaw is renowned for its tortuous, serpentine course.

The Waccamaw drains 1,295 square miles of land, 782 square miles being in North Carolina. The total distance covered by this river is 244 miles, which was navigable all the way up to the lake for boats of less than three-foot draft. In the days of old, steamboats could travel 163 miles upstream from the river's mouth.

Both the lake and river take their name from a tribe of Indians who were living in the area in the early eighteenth century when the first settlers arrived. Colonel John "Tuscarora Jack" Barnwell is credited with giving both the lake and river their name. In 1712, upon his return to South Carolina after his campaign against the Tuscarora, Barnwell led his men overland to Lake Waccamaw. From there they traveled down the Waccamaw River, all the way to Winyah Bay.

On the Barnwell-Hammerton map of 1721, the river and lake are shown for the first time. The cartographer, believed to have been

# The Pee Dee

Barnwell himself, labeled the lake Wacomow Lake, and the river he labeled Wacomaw River. A notation is included alongside the river and lake, pointing out "Coll. Barnwell's Return in 1712."

WEST BRANCH ROCKY RIVER rises southwest of Mooresville in Iredell County and flows south/southeast into Mecklenburg County. It enters Rocky River on the Cabarrus County line.

WEST FORK LITTLE RIVER rises in the Uwharrie Mountains in Randolph County and flows southeast to the Randolph/Montgomery line, then meanders south to its confluence with Little River between Star and Troy. Pisgah Covered Bridge spans the West Fork Little River in southwestern Randolph County. The bridge, originally built in 1911, is one of only two covered bridges remaining in North Carolina.

WEST PRONG LITTLE YADKIN RIVER rises northwest of Sauratown Mountain and flows through the valley between Sauratown Mountain and Pilot Mountain. It unites with the East Prong Little Yadkin River near the community of Chestnut Grove to form Little Yadkin River.

WEST PRONG ROARING RIVER rises in western Wilkes County near Little Grandfather Mountain and flows in a southeasterly direction to its junction with Middle Prong Roaring River near Dockery.

YADKIN RIVER rises near the Blue Ridge Parkway northeast of Blowing Rock and flows south into Caldwell County. It flows southwest between Fork Mountain and Ripshin Mountain, then turns south between Ripshin Mountain and Johnny's Knob. At Happy Valley, the Yadkin turns northeast and maintains that course as it flows between the Blue Ridge and Brushy Mountains. Near Wilkesboro, the waters of the Yadkin are dammed by W. Kerr Scott Dam. The distance from this dam to Winyah Bay, South Carolina, is 388 miles.

From Wilkesboro, the Yadkin continues in a northeasterly direction before turning south near Pilot Mountain. The river meanders south by Winston-Salem. At the mouth of the South Yadkin River, the Yadkin turns southeast and flows between Salisbury and Lexington, past High Rock Mountain. The Yadkin is joined by the Uwharrie River at Morrow Mountain State Park. The junction of these two rivers is considered to be the beginning of the Pee Dee River. The distance from W. Kerr Scott Dam is 135 miles.

# NORTH CAROLINA RIVERS: FACTS, LEGENDS AND LORE

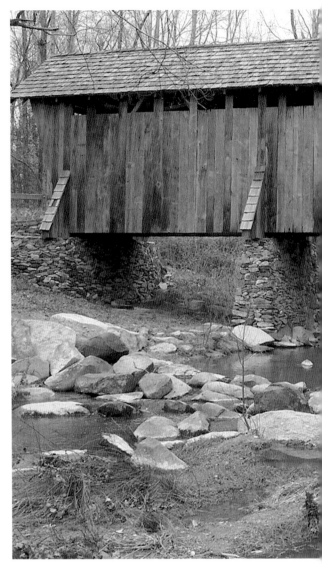

The Pisgah Covered Bridge crosses the West Fork Little River near the community of Pisgah in Randolph County. This is one of the few remaining covered bridges in the state.

In 1856, Charles Fisk, chief engineer of the Yadkin Navigation Company, examined the river from Holmes' Mill, which was fifteen miles downstream from the spot where the North Carolina Railroad crossed the Yadkin, upstream to the town of Rockford, ninety-four miles upstream from the bridge. He found the total fall between these points to be 226½ feet. He noted that the river drops 85 feet in the sixteen miles upstream from Bean Shoals, and 141½ feet between Big Shoals and Holmes' Mill.

# The Pee Dee

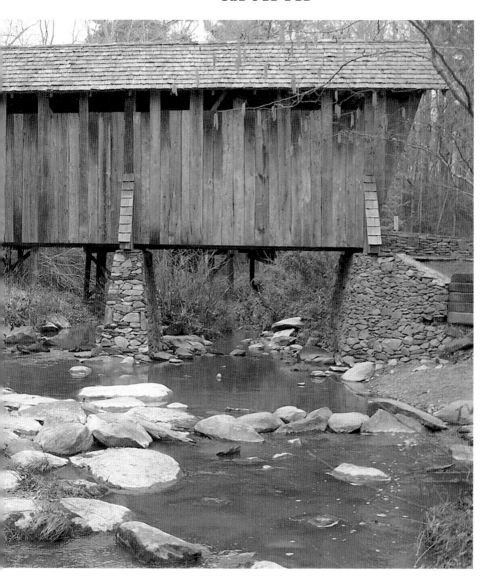

Just downstream from the Bull Island Shoals was located the famed Narrows of the Yadkin, a landmark that marked the entrance to a three-mile gorge cutting through the solid bedrock as the Yadkin tore its way through the Uwharrie Mountains. The gorge contained rapids including the Narrows, Little Falls and Big or Great Falls, dropping ninety-one feet in elevation as it made its way to the mouth of the Uwharrie River. But it was the way in which the river was constricted by the nearly impervious bedrock

# NORTH CAROLINA RIVERS: FACTS, LEGENDS AND LORE

Bean Shoals was one of the major impediments to navigation along the upper reaches of the Yadkin River. The remains of a canal built to bypass these rapids can still be seen along the north shore of the river. The area is now part of Pilot Mountain State Park.

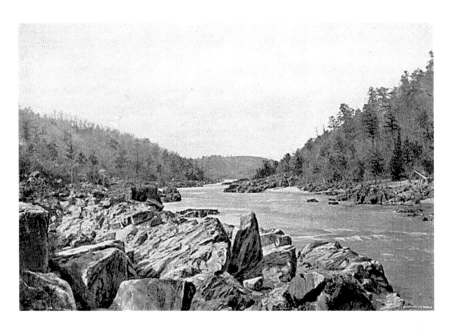

This image of the Yadkin Narrows was published by the North Carolina Geological Survey in 1896. It shows a part of the rock gorge through which the Yadkin passed as it made its way through the Uwharrie Mountains. The site is now under the backwaters of Falls Dam near Badin.

# The Pee Dee

that made the Narrows such a notable place. The Narrows of the Yadkin proved to be an insurmountable obstacle to those who wished to utilize the Yadkin as a transportation artery.

In 1899, G.F Swain and J.A. Holmes wrote a description of this part of the river.

> *The section of the river for five miles above the mouth of the Uharie is quite different in character from that both below and above this region. Over the shoals just described and those described further on as occurring higher up the stream, the bed of the river spreads out to a width of from 1000 to 1500 feet, and at Grassy Island is not less than one-half mile wide. But in the three and one-half miles under consideration the river runs through a deep, narrow gorge, and here, perhaps, the most remarkable waterpower in the state occurs at the "Narrows of the Yadkin." At the upper end, before reaching the Narrows, the river is nearly or quite 1000 feet wide, from which it suddenly contracts, entering a narrow ravine between the hills, which rise abruptly on either side with rocky and almost perpendicular banks, and through which it pours with great violence, preserving for a distance of about a mile an average width of not over 150 feet, while in some places the width is only 60 feet. No description can do justice to this place, which is one of the most wonderful spots that can be found in the South.*

The first attempt to harness the power of the Yadkin near the Narrows was started by George Whitney, a wealthy industrialist from Pittsburgh who had plans of harnessing the natural resources of the Yadkin Valley. In 1901 he began construction of a granite dam at the head of the Narrows, but by 1907 his company was bankrupt, having lost $19 million on the venture. Remains of his works can still be seen in Badin Lake during periods of low water.

In 1912, Whitney's works were purchased by L'Aluminium Francais, a French company that hoped to harness the river to produce electricity to power its aluminum smelting operations. They decided to dam the river just downstream from where Whitney had begun his structure. The Frenchmen made much progress at the site, but the advent of World War I resulted in their abandoning the effort before it was completed. The French company sold the site to the Aluminum Company of America (ALCOA) in 1915.

Within two years of purchasing the site, the company completed the Narrows Dam, creating the reservoir now known as Badin Lake. This was

# NORTH CAROLINA RIVERS: FACTS, LEGENDS AND LORE

Little Tennessee River upstream from the Town Creek Indian Mound.

the first of four dams ALCOA built along this thirty-eight-mile stretch of river. The next dam to be completed was Falls Dam, built a few miles downstream at the lower end of the Narrows near the Great Falls in 1919. High Rock Dam, located fifteen miles upstream from the Narrows Dam, was completed in 1927. The Tuckertown Dam was the fourth and final dam constructed by ALCOA, built across the river near the NC 49 bridge in 1963.

No one really knows the origin of the word Yadkin. In 1957, Dr. Douglas Rights, an authority on the Indians of North Carolina, wrote, "The meaning of the word *Yadkin*, derived from *Yattken*, or *Yattkin*, a Siouan Indian word, is unknown. In Siouan terminology it may mean 'big tree,' or 'place of big trees.'"

The river is also referred to by the name Sapona in some of the old sources, including John Lawson's *A New Voyage to Carolina*. On Edward Mosely's map compiled in 1733, the river is marked "Sapona or Yatkin River."

CHAPTER 5

# The Santee

The Santee River Basin stretches southeast to northwest across South Carolina and North Carolina. The basin drains approximately 15,700 square miles of land, 10,400 square miles of which are in South Carolina and 5,300 square miles in North Carolina.

An overview of the basin shows that it flows across all of the physiographic regions of the Carolinas. Its headwater streams drain some of the highest peaks in the Blue Ridge, while much of the lower reaches of the river are located in a wild area filled with swamps and bottomlands. In between, the waters are now backed up in a series of lakes where in the not too distant past the rivers tumbled across the Piedmont before reaching the Coastal Plain.

In order to understand why the Santee River Basin is significant to a study of North Carolina rivers, one needs to understand how the various rivers of the system come together. The Catawba River flows out of the Blue Ridge in a giant arc across western North Carolina. Upon crossing into South Carolina, it joins Wateree Creek and becomes the Wateree River. Meanwhile, Broad River and its tributaries drain the area south of the Catawba and flow into South Carolina near Shelby. The Saluda and Broad Rivers join at Columbia, where the Congaree River begins. This river flows 51 miles southeast to its junction with the Wateree, where the Santee River officially begins. From this point, along the main branch of the Santee River, the river flows a distance of 143 miles to the ocean. However, much of the river's waters are diverted in the Santee-Cooper

# NORTH CAROLINA RIVERS: FACTS, LEGENDS AND LORE

Lakes project and end up flowing into the Cooper River and eventually into Charleston Harbor, where the waters finally make their way to the Atlantic.

BOWENS RIVER rises near the community of Earl in Cleveland County and flows southwest into South Carolina. It enters the Broad River west of Blacksburg, South Carolina. The river is believed to have taken its name from an early settler.

BROAD RIVER rises on the Blue Ridge south of the town of Black Mountain in Buncombe County between Dill Knob and High Top Mountain. It flows northeast for a short distance before making a bend to the southeast and flowing in that general direction until heading in a more southerly direction at the base of Cross Mountain. The river travels past Rattlesnake Knob, and at Camp Minnehaha it flows across Minnehaha Falls. It then makes a sharp bend to the east at its junction with Hickory Creek at Bat Cave. Here the river enters the famed Hickory Nut Gorge, with Bald Mountain and Round Top Mountain to the north and Blue Rock Mountain and Chimney Rock Mountain to the south. As it exits Hickory Nut Gorge, the Broad enters the backwaters of Lake Lure, which was formed by damming Broad River. The river veers southeast near Vree and continues in that direction until south of Rutherfordton, where the Broad takes a more easterly course parallel to the South Carolina line into Cleveland County. After its junction with the First Broad River, the Broad veers back to the southeast and crosses into South Carolina. At Columbia, the Broad and the Saluda flow together to form the Congaree River.

In 1799, the State of North Carolina attempted to establish a town named Jefferson on the Broad River near the South Carolina line. The site, in that part of Rutherford County that is now in Cleveland County, was located on a fifty-acre tract of land. The town was envisioned by its creators as being an inland port where farmers could transport their goods by river to markets in Columbia. Jefferson would have acted as a magnet, drawing farmers from the surrounding hills into town to sell their commodities and spend their hard-earned wages.

All of this was dependent upon making Broad River navigable, which did not happen this far upstream. Thus, despite the fact that the Rutherford County justices continued to fill vacancies on the Jefferson town commission, the town along the Broad River with so much potential faded into oblivion.

# THE SANTEE

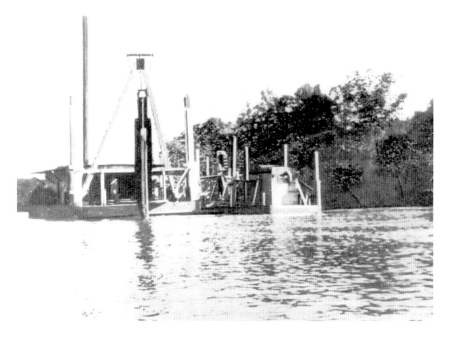

This dredge shown working in the early twentieth century on the Catawba River near Belmont was exploring the bottom of the river looking for gold.

Mooney notes that the Cherokee and Catawba fought a fierce but indecisive battle for possession of the land along the headwaters of the Catawba River. Afterward, they settled upon a common boundary that left the Cherokee to the west of Broad River, the Catawba to the east of Catawba River and the land between became a common hunting ground. In honor of this, the Catawba referred to Broad River as "Eswau Huppeday," or as Mooney translated it, "Line River."

CATAWBA RIVER begins on Evans Knob near Black Mountain and flows east/northeast past Old Fort, Marion, Morganton and Hickory. At Lookout Shoals, the Catawba is deflected to the south and flows into South Carolina southwest of Charlotte.

The largest of the rapids on the Catawba in North Carolina was Lookout Shoals, near the town of Catawba. According to surveys made in the 1800s, the river descended over fifty feet as it made its way through these rocky rapids that stretched three-quarters of a mile along the river. The energy of these rapids is now harnessed by Duke Energy, thanks to the Lookout Shoals Hydroelectric Station, built in 1915.

# NORTH CAROLINA RIVERS: FACTS, LEGENDS AND LORE

After passing the mouth of the South Fork Catawba River, the Catawba passes into South Carolina. It flows along for fifty-five miles to the mouth of Waterree Creek, where the name of the river changes to Wateree River. Two sets of rapids along this section of the Catawba—Rocky Mount Shoals and Landsford Shoals—were particularly troublesome to those traveling along the river and impeded navigation. J.M. Wolbrecht, who examined the river for the corps of engineers in 1879, declared, "These two shoals are the most formidable of the obstructions on the Catawba in either of the states."

Wolbrecht described this stretch of river.

> *The obstructions were found to consist of rocks, shoals and falls, the natural consequences of the concentration of the river's descent at a few points and for short distances. The principal of the natural obstructions are Rocky Mount Shoals and Landsford Shoals. The former of these consists of a succession of falls and cataracts without intermission, for a distance of nearly 8 miles. At one place the fall is 50 feet in less than ¼ of a mile. The total fall as mentioned is 178 feet. Landsford Shoal is about 2 miles in length, and falls 29 feet, on a gradual incline.*

In the early 1800s, a canal was dug to bypass these obstructions in the river. These improvement efforts eventually failed, but the remains of the canal can still be seen at Landsford Canal State Park.

The Wateree River flows south for 105 miles and unites with the Congaree River to form the Santee River. The Santee flows in a southeasterly direction and enters the Atlantic Ocean 143 miles downstream from the point where it begins. The mouth of the river is located between Winyah Bay and Charleston. Though this is South Carolina's mightiest river, the Santee never developed into a major shipping port because shoals and sandbars at the river's mouth impeded navigation.

From its source above Old Fort to the mouth of the Santee is a distance of nearly 450 miles. The distance from Old Fort to the mouth of Wateree Creek is 195 miles.

The Catawba/Wateree flows 334 miles from its beginning to its junction with the Congaree River. In that distance, the Catawba descends nearly 2,600 feet in elevation.

The Catawba was once a wild river full of raging rapids, but a series of hydroelectric projects has tamed the river to the point that it is now merely a series of lakes for most of its existence in North Carolina. These lakes are Lake James (1929), Lake Rhodiss (1925), Lake Hickory (1928),

# The Santee

Lookout Shoals Lake (1915), Lake Norman (1963), Mountain Island Lake (1924) and Lake Wylie (1926).

Cowans Ford Shoals was a set of rapids that stretched four miles along the river on the Lincoln and Mecklenburg County line. Here the river descended over twenty-seven feet. The site was an important crossing spot along the river. During the Revolutionary War, the Battle of Cowan's Ford was fought here as Whig troops under William R. Davie fought a delaying action against Lord Cornwallis and his British forces who were attempting to catch and destroy General Nathanael Greene's army.

In 1963, Cowans Ford Dam was built by Duke Power to harness the energy of the river. The concrete dam stretches 1,279 feet across the Catawba and stands 130 feet tall. Cowans Ford Dam creates Lake Norman, which is North Carolina's largest lake. The lake covers 32,475 acres and has 520 miles of shoreline.

The river's name is derived from a prominent Indian tribe that once inhabited the area along the North Carolina/South Carolina line.

First Broad River begins at the junction of the North Fork First Broad River and the Little First Broad River. It flows south past the town of Fallston and enters the Broad River south of the town of Shelby. The river is characterized by a steady, even drop from its source to its junction with the Broad, and there is an absence of any major whitewater waterfalls.

Originally this river was known as the Sandy River. Several early maps, including Captain John Collet's "A Compleat Map of North-Carolina," published in 1770, show the Sandy River as a prominent watercourse in the area. The name was dropped, and First Broad came to be the commonly accepted name for this river by the end of the 1700s.

Green River rises in southwestern Henderson County near Turkey Knob and flows northeast between the Saluda Mountains and the Blue Ridge into Polk County. Not too far from its source, the Green River is impounded by the Tuxedo Hydroelectric Plant, which creates Lake Summit. The hydroelectric plant was completed in 1920 by the Blue Ridge Power Company, which subsequently sold the facility to Duke Power in 1929. The dam stands 254 feet tall.

After flowing out of Lake Summit, Green River flows in a northerly direction and passes under the Interstate 26 bridge. The I-26 bridge is the highest bridge in North Carolina, spanning the Green River 225 feet above the river's surface.

The Green River near the community of Pea Ridge in Polk County.

The Green River veers east into Polk County and passes into the Green River Gorge, one of the most rugged river gorges in the state. Here the river rushes over several series of rapids as it drops off the Blue Ridge Escarpment. The river descends four hundred feet through

# The Santee

a mile-and-a-half section and passes through a six-foot-wide passage through solid bedrock known as the Narrows. There are several interesting rapids in the Narrows, including a particularly challenging one called "the Gorilla."

# NORTH CAROLINA RIVERS: FACTS, LEGENDS AND LORE

The Green River Gorge is part of the Green River Game Lands, a ten-thousand-acre tract of land administered by the North Carolina Wildlife Resources Commission. The original portion of this preserve was purchased back in 1994 by the Nature Conservancy, which turned the land over to the state.

After flowing out of Lake Adger, the Green River travels east, then southeast. Downstream from the U.S. 74 bridge, the river joins Broad River on the Rutherford County line south of Rutherfordton.

HENRY FORK RIVER rises in South Mountain State Park and flows northeast to Hickory, where it bends to the southeast. It unites with Jacobs Fork west of Newton to form South Fork Catawba River.
    The river is named for Heinrich Weidner, an early settler.

HUNGRY RIVER rises in northwestern Henderson County between Sugarloaf Mountain and Wildcat Spur. It flows southwest for approximately ten miles and joins Green River north of Saluda.

JACOBS FORK RIVER rises in South Mountain State Park in Burke County. It flows east/northeast to its junction with Henry Fork, where South Fork Catawba River begins.
    The river is named for Jacob Shuford, an early settler.

JOHNS RIVER rises near Blowing Rock and flows south until it joins the Catawba River near Morganton and the backwaters of Lake Rhodhiss.
    The Johns River Gorge is one of the most visited sites in the northwestern part of the state, as the popular tourist attraction Blowing Rock is located on its rim. The wind currents that blow up the gorge are funneled up the rock outcropping and will usually return a light object that has been cast over the precipice back to the thrower.
    Johns River reportedly takes its name from John Perkins, an early settler who once owned land along its banks.

LEFT PRONG CATAWBA RIVER rises on Cross Mountain in McDowell County and flows northeast by Hicks Mountain and Edmondson Mountain to its confluence with the Catawba.

# THE SANTEE

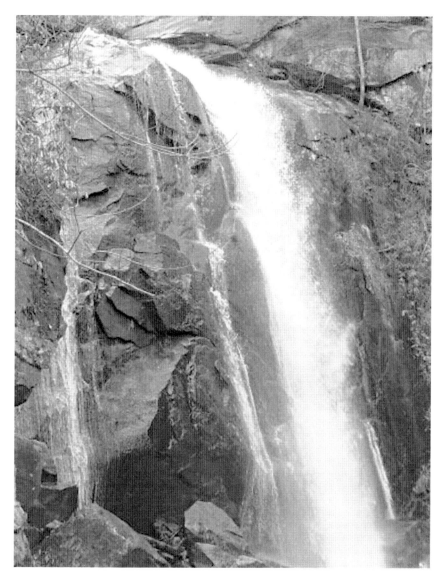

High Shoals Falls along Henry Fork River in the South Mountains State Park.

LINVILLE RIVER rises in Avery County in Linville Gap near Grandfather Mountain and flows southwest by the towns of Linville and Crossnore. After passing the Blue Ridge Parkway the Linville River takes a more southerly course and plunges over Linville Falls, a popular tourist attraction.

# NORTH CAROLINA RIVERS: FACTS, LEGENDS AND LORE

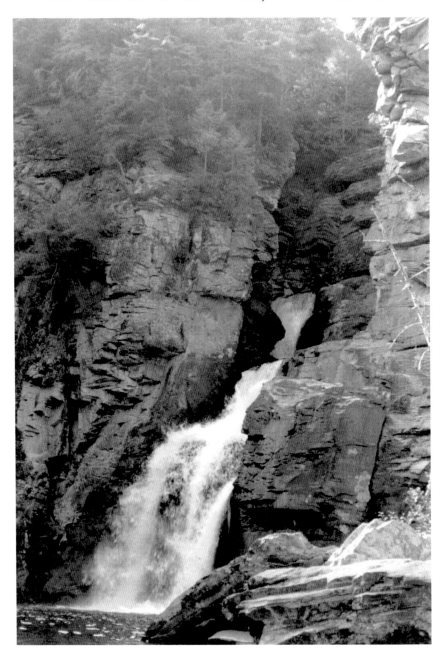

Linville Falls is one of the most spectacular waterfalls in North Carolina. Here, the Linville River drops ninety feet across the lower falls as it descends into the plunge basin. The falls are now owned by the National Park Service, which administers the site as a component of the Blue Ridge Parkway.

# The Santee

Linville Gorge stretches fourteen miles downstream from Linville Falls. It was created as the Linville River carved a gash in the earth as it tumbled down onto the Piedmont to join the Catawba. In some places, the difference in elevation between the river and the rim of the gorge is over two thousand feet in elevation.

Linville Gorge is often referred to as "the Grand Canyon of the East." Several rocky peaks tower above the gorge, including such prominent mountains as Shortoff Mountain, Table Rock and Hawksbill Mountain. There are other lesser-known cliffs, such as the North Carolina Wall and the Chimneys. Today, the Linville Gorge is one of the most recognized rock-climbing destinations in the Southeastern United States.

In the 1890s, W.S. Walton, an engineer from Morganton, made several measurements of the gorge and falls. His measurements showed that the river descended an average of 208 feet per mile for the first six miles below the base of the falls. He also noted that from the top of Linville Falls to a point ten miles downstream the river descended 1,800 feet.

The Linville River emerges from the gorge and enters the backwaters of Linville Dam, which forms Lake James. Here it unites with the Catawba, but before the dam was constructed, the two rivers did not unite until a few miles downstream at the mouth of what is today called Old Catawba River.

The Native Americans referred to the Linville River as Eeseeoh, "River of Many Cliffs." The river received its current name in honor of William Linville, an early settler who hunted and explored in the mountains of western North Carolina in the 1700s. In 1766, while on a hunting trip along the Linville River, he and his son were ambushed and killed by a war party of Indians who were returning north from a raid against the Cherokee. The attack is thought to have taken place near the mouth of the gorge, downstream from Linville Falls.

LITTLE FIRST BROAD RIVER rises on the east flank of South Mountain and flows southeast to its intersection with North Fork First Broad River to form First Broad River.

LITTLE HUNGRY RIVER rises on Poplar Mountain in eastern Henderson County and flows southwest by Point Lookout Mountain to its junction with Hungry River at Baxter.

LITTLE RIVER rises in the South Mountains of Burke County. After cascading over several waterfalls, the river flows into Jacobs Fork River.

# NORTH CAROLINA RIVERS: FACTS, LEGENDS AND LORE

LITTLE TOE RIVER rises in McDowell County in the mountains southeast of Old Fort. It winds in an easterly direction along the south side of Jacks Mountain. The total length of the river is approximately three miles. U.S. Geological Survey maps show this river to be a tributary of Crooked Creek, which flows into the Catawba River.

LOWER LITTLE RIVER flows south out of the Brushy Mountains near Millersville. The river turns east for a short distance before making a gradual bend to the southeast. It joins the Catawba River on the Alexander/Catawba County line.

MIDDLE LITTLE RIVER begins northwest of the town of Draco and then flows southeast until it empties into Lake Hickory. Here it unites with the Catawba. As this is the second "Little River" to be encountered out of the three on this part of the Catawba, it has been designated "Middle" to help distinguish it from its neighbors.

NORTH FORK CATAWBA RIVER rises near the town of Linville Falls in Avery County and flows south past Linville Caverns, then south/southwest between Linville Mountain and Honeycutt Mountain until near the town of Sevier, where it gradually turns to the south and enters the Catawba River in the backwaters of Lake James north of Marion.

NORTH FORK FIRST BROAD RIVER rises in the South Mountains of Burke County and begins at the intersection of Negro Creek and Roper Creek in Rutherford County. It flows south/southwest to its junction with Little First Broad River to form First Broad River.

NORTH PACOLET RIVER rises in the gap between Hetherly Height and Smoky Mountain in Henderson County, and flows southeast through Lake Hosea. At the base of Evans Mountain, the river is deflected to the northeast and continues in that direction into Polk County. At the junction with Joels Creek, the North Pacolet takes a turn more toward the east as it flows through a steep, rugged gorge. The valley widens somewhat as the river passes Cedar Cliff and Little Warrior Mountain on its way through the town of Valhalla. As it flows around the north side of Tryon, the river bends back toward the southeast. After passing under the I-26 bridge, the river takes a turn to the south and flows approximately three miles before crossing into South Carolina. Less than a mile after

crossing the border, the North Pacolet turns to the east and parallels the North Carolina/South Carolina border for several miles until reaching the community of Little Africa, at which place the river turns back toward the south/southeast. It joins the South Pacolet River near Fingerville, where the Pacolet officially begins.

The treaty ratified in 1767 establishing a boundary between the Cherokee and the European settlers referred to this river as "Packolato Creek." Some maps show the North Pacolet as a continuation of the Pacolet. Published in 1755, John Mitchell's "A Map of the British and French Dominions in North America" labels the stream "Packolet R." This is the earliest map to show the river with this name.

The origin of the name has been attributed to several sources. According to one legend, it is French and was named for a now-forgotten French explorer who traversed the area. Some maintain that it is derived from the term "Pacolette," owner of a mythical horse that could magically transport its rider anywhere in the world in an instant. Others state that it was derived from an Indian word meaning "running horse."

OLD CATAWBA RIVER runs from the Catawba River Dam on Lake James to its intersection with Catawba River downstream from Linville Dam. This was the bed of the Catawba River before Linville Dam was built, which diverted the river's flow into Lake James. The river rejoins its former bed, now called Old Catawba River, below the dam.

SECOND BROAD RIVER rises near the town of Providence in McDowell County and flows southeast between Lewis Mountain and Jones Mountain. It makes a southerly turn near Vein Mountain and crosses into Rutherford County, where it continues heading south/southeast by Logan, Forest City, Caoleen, Henrietta and Cliffside. The river enters Cleveland County and flows into Broad River.

SOUTH FORK CATAWBA RIVER begins in Catawba County at the confluence of Henry Fork and Jacobs Fork. It flows south into Lincoln County. Near Long Shoals on the Gaston County line, the South Fork Catawba River turns southeast and flows by Spencer Mountain and Gastonia. It enters the Catawba River near the South Carolina line in the backwaters of Wylie Dam.

The first cotton mill erected in the state of North Carolina was built across the South Fork Catawba River near Lincolnton, circa 1814, by Michael Schenck and Absalom Warlick. This mill operated only briefly,

This Lower Little River is a tributary of the Cape Fear.

and was destroyed by a flood in 1818. But other mills soon followed, and the area between the Catawba and Broad Rivers, especially along the South Fork Catawba, remained an important textile manufacturing region in North Carolina into the twentieth century.

# The Santee

This river was once known as Clark's River, as evidenced by a land grant for one thousand acres in Anson County to John Clark dated October 7, 1749, which was located "on Clarks river—being the S. fork of the Catawba." The river is also known as Little Catawba River.

A helicopter lowering a section of a bridge utilized as a crossing of the North Fork of the Catawba River for the Mountains to the Sea Trail. *Courtesy of Jeff Brewer, Friends of the Mountains to the Sea Trail.*

# The Santee

## NORTH CAROLINA RIVERS: FACTS, LEGENDS AND LORE

SOUTH PRONG GREEN RIVER rises near Standingstone Mountain and flows northwest for about a mile before turning northeast to the Green River.

UPPER LITTLE RIVER rises in the hills northwest of the community of Oak Hill. It flows southeast to where it unites with the Catawba at Lake Hickory, north of the town of Hickory. In the late eighteenth century, this river was also referred to as Clark's Little River, named for an early settler.

WEST FORK LINVILLE RIVER rises on Flattop Mountain in Avery County and flows south by Briar Knob to its confluence with the Linville River near the town of Linville.

CHAPTER 6

# The Savannah River Watershed

One of the most famous rivers in the Southeast, Savannah River drains over fifteen thousand square miles of land in Georgia, North Carolina and South Carolina. Only a small part of the drainage basin is located in North Carolina. All of the North Carolina tributaries are located high in the Blue Ridge Mountains of the southwestern part of the state. Some of the state's most spectacular waterfalls are located along the river in this section.

CHATTOOGA RIVER is famous throughout the world as a Georgia tourist attraction, but it actually begins in North Carolina near Cashiers in Jackson County, from where it flows over the border to form the boundary between North Carolina's two neighbors to the south. This stream gained fame through the film *Deliverance*, whose whitewater scenes were filmed upon its waters, mainly in Georgia.

The most prominent landmarks on the upper reaches of the Chattooga are two rock inscriptions that are located on the east bank of this river where it leaves North Carolina. Both are known as Ellicott's Rock, for Major Andrew Ellicott, a surveyor hired in 1811 by Georgia in an effort to locate the true northern boundary of that state and end the border disputes with her northern neighbor. Where Ellicott's line struck the Chattooga on the east bank he carved the letter "N" on the North Carolina side and "G" on the Georgia side.

## NORTH CAROLINA RIVERS: FACTS, LEGENDS AND LORE

The other Ellicott Rock is located a short distance away. It was carved by commissioners from North and South Carolina who were on the same mission as Ellicott. Ignorant of their predecessor's mark, the carved stone where their measurements showed that the thirty-fifth parallel struck the Chattooga was carved on a nearby rock. Their inscription reads "Lat 35 AD 1813 NC SC." Ellicott's original rock carving was forgotten, and the 1813 rock became known as Ellicott's Rock. Both rocks were rediscovered in 1970 by Henry Wright, who reported his findings in *The State Magazine*.

After it crosses into Georgia, the Chattooga becomes a Mecca for whitewater enthusiasts from throughout the world. Some like to attempt to run the river in North Carolina, but most prefer to challenge the river farther down after it has picked up more volume. Its waters eventually flow into the Atlantic at Savannah, Georgia.

Portions of the Chattooga are protected by the federal government as part of the National Wild and Scenic Rivers program.

According to Mooney, the origin of the name is uncertain, and is quite possibly from another tribe of Indians besides the Cherokee, who gave names to so many other landmarks in the southern Appalachians. He records the name as "Tsatugi," and notes, "Possible Cherokee derivations are from words signifying, respectively, 'he drank by sips,' from gatu gia, 'I sip,' or, 'he has crosses the stream and come out upon the other side,' from gatu gi, 'I have crossed.'"

COLEMAN RIVER rises on the Blue Ridge in extreme southeastern Clay County, approximately one half-mile north of the Georgia border. It flows south/southwest through the Coleman River Wildlife Management Area of the Chattahoochee National Forest to its junction with the Tallulah River. The origin of the river's name is a mystery.

EAST FORK CHATTOOGA RIVER rises on the flanks of Flat Mountain and flows south into South Carolina, where it eventually cuts west to join the Chattooga on the Georgia border. This river flows through a remote and rugged area, hence it gets few visitors. Some of the more hardy and adventurous kayakers have been known to tempt its whitewater.

HORSEPASTURE RIVER rises on the Blue Ridge north of Cashiers and flows east through Sapphire Lake and by the town of Sapphire. It bends southeast near Oakland and continues that course to the South Carolina line and Lake Jocassee.

# THE SAVANNAH RIVER WATERSHED

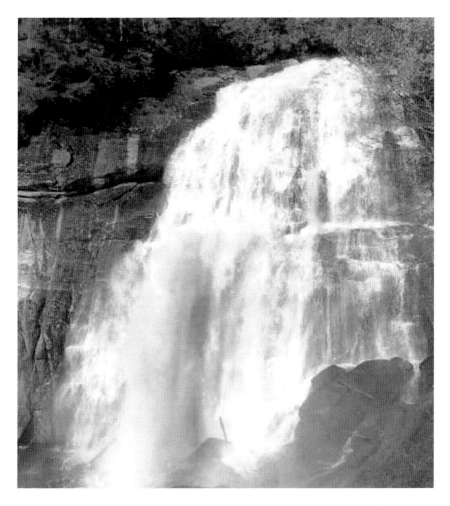

The Horsepasture River plunges 125 feet across Rainbow Falls. In October of 1986, a 4.2-mile section of the Horsepasture River was named a National Wild and Scenic River.

As the river plunges off the Blue Ridge Escarpment, it cascades over several picturesque waterfalls, including Turtleback Falls, Stairstep Falls, Drift Falls and Windy Falls. The most famous of these waterfalls on the Horsepasture is Rainbow Falls, where the river plunges over 150 feet down the face of a cliff. Often the sun shining through the mist at the bottom of the falls creates a rainbow, hence the name.

On October 26, 1986, a 4.2-mile section of the Horsepasture River officially became a part of the National Wild and Scenic River System.

# NORTH CAROLINA RIVERS: FACTS, LEGENDS AND LORE

The section includes the river from North Carolina 281 to Lake Jocassee. It is the shortest portion of a river so designated in the entire country.

TALLULAH RIVER begins at the confluence of Deep Gap Branch and White Oak Creek on the flanks of Standing Indian Mountain (elevation 5,499 feet above sea level) in the Nantahala Mountain Range. The Tallulah flows in a southerly direction across the North Carolina/Georgia border and joins the Chattooga River to form the Tugaloo River near Tallulah Gorge, Georgia.

The total distance of this stream from its headwaters to the Georgia line is about five miles. Once in Georgia, the Tallulah passes through the town of Tallulah Falls before it enters into picturesque Tallulah Gorge. Tallulah Falls, named for a nearby waterfall, was a fashionable resort for many residents of Atlanta and Athens around the end of the nineteenth century. The gorge is also famous as many of the scenes for the film *Deliverance* were filmed along its precipitous cliffs.

There are several interesting legends surrounding the meaning of the name "Tallulah." One of the more interesting was recorded by Mooney, who noted, "One informant derives it from talulu, the cry of a certain species of frog known as dulusi, which is found in that neighborhood, but not upon the reservation, and which was formerly eaten as food."

THOMPSON RIVER rises in Transylvania County between Rainy Knobs and Sassafras Mountain. It flows southeast, then turns south and flows between Long Spur Ridge and Misery Mountain before crossing the state line into South Carolina. Thompson River joins the Whitewater River at Hester Mountain in South Carolina, in the backwaters of Lake Jocassee.

TOXAWAY RIVER rises near Panthertail Mountain in western Transylvania County and flows southeast into Lake Toxaway. Just below the dam and U.S. 64, the river plunges over Toxaway Falls. The river continues southeast by Grindstone Mountain before bending southwest and entering the backwaters of Lake Jocassee and South Carolina.

Mooney noted that the name Toxaway was applied to both the river and a settlement of Cherokee at the head of Keowee River. He wrote, "It has been incorrectly rendered, 'Place of shedding tears,' from dasa was ihu, 'he is shedding tears.' The correct Cherokee form of the name is Duksai or Dukwsai, a word which can not be analyzed and of which the meaning is now lost."

# The Savannah River Watershed

WHITEWATER RIVER rises near Chimneytop Mountain southeast of Cashiers and flows southeast for approximately six miles to Whitewater Falls, one of the most impressive waterfalls in the state. At Whitewater Falls, the river roars more than 800 feet down off the Blue Ridge Escarpment into South Carolina. There are some who advocate this set of falls as the highest in the Eastern United States. However, although the total height of the falls is often credited at over 800 feet, the 411-foot-tall Upper Section and the 400-foot-tall Lower Section are separated by nearly two miles. Historically, people have distinguished the falls as separate entities, referring to North Carolina's portion as Upper Falls and the lower section just across the state line in South Carolina as Jocassee Falls or the Lower Falls.

Even with its height halved, Whitewater Falls is still quite impressive. In his book *Waterfalls of the Southern Appalachians*, Brian Boyd declares, "Whitewater Falls is the absolute king of all cascades in the Southeast. Not only is it the highest unbroken cascade at 411 feet, but it occurs along a stream of considerable volume—the Whitewater River."

Approximately a mile downstream from Jocassee Falls, the Whitewater River flows into Lake Jocassee. The river joins Toxaway River in the backwaters of Lake Jocassee to form the Keowee River.

A fishing boat tied up to the dock alongside the Calabash River. *Courtesy of Joey Powell.*

# Chapter 7

# Coastal Rivers

Most of North Carolina's rivers empty into the drainage basin of a larger river such as the Cape Fear or Roanoke. However, there are a few smaller rivers in the southeastern part of the state that flow directly into the ocean or empty into an estuary that is not part of the Albemarle-Pamlico Basin. Thus, they have their own individual drainage basins.

CALABASH RIVER begins in the southwestern part of Brunswick County and flows west about five miles before crossing the border into South Carolina. There it empties into Little River and flows into the Atlantic via Little River Inlet.

The town of Calabash is world famous for its seafood. Numerous restaurants line the waterfront of this small coastal village, and all are usually full of diners during the summer months.

The name Calabash was given to the river because of the profusion of wild gourds that grew along its banks. Many of these were hung by wells and used by local residents as drinking utensils.

LOCKWOODS FOLLY RIVER begins east of Supply, where Middle Swamp and River Swamp converge. The river flows west to Supply and then turns southwest to the sea. It enters the Atlantic through Lockwood Folly Inlet near Holden Beach.

# NORTH CAROLINA RIVERS: FACTS, LEGENDS AND LORE

The New River as it flows by Jacksonville in Onslow County.

There are a couple of interesting stories extant as to how this river obtained its name. Both involve a gentleman named Lockwood. The first story states that a Mr. Lockwood began building the boat of his dreams along the banks of the river. He worked tirelessly for many months until one day he was finally finished and his beautiful sailing ship was completed. Then disaster struck. As he tried to float his dreamboat into the ocean, Lockwood found that he had made it of too deep a draft to clear the bar at the inlet. Disappointed, he left the ship to rot in the river, and the locals began calling the ship "Lockwood's Folly." Eventually the name was applied to the river and inlet.

The other story, and the more plausible one, states that the river was so named due to a failed colonizing attempt. Supposedly Lockwood, the leader, either did not bring along enough supplies or ran afoul of the Indians. Either way, the settlement was abandoned and the name of the site of the ill-fated colony became Lockwood's Folly. As the years passed, the name was given to the river.

No matter how the Lockwoods Folly River got its name, it is among the oldest names for a river in North Carolina. It appears on the Ogilby Map of 1671, which means the name has been in use for over three hundred years.

# Coastal Rivers

NEW RIVER rises in northern Onslow County near Jarmantown and flows southeast to Jacksonville. At this point, the river widens considerably, especially after Northeast Creek and Southeast Creek flow in.

The New continues southeast through Camp Lejeune Marine Base. The base is named for Major General John Lejeune. It was originally known as New River Marine Base when it was established in 1942. Prior to this, the New River's main claim to fame was its excellent fishing.

The New takes a westward turn south of Camp Lejeune and resumes traveling southeast a few miles beyond until it flows into the Atlantic Ocean via New River Inlet.

Downstream from the bustling town of Jacksonville, a quiet point of land jutting out into the New River stands as a mute testimony to the awesome power of nature. Here once stood the old town of Johnston, whose short existence was brought to an abrupt end during one of the most violent hurricanes ever recorded along the North Carolina coast.

The town was created in 1741 when the general assembly voted to erect a town to serve as the seat of government for Onslow County. Located at Town Point, which at the time was called Mittam's Point, this was the third county seat since Onslow's creation as a precinct in 1731. The town was called Johnston in honor of Governor Gabriel Johnston, who was then in the middle of what would turn out to be an eighteen-year term.

A commission composed of Governor Johnston's brother and Surveyor General Samuel Johnston, John Starkey, Jonathan Freemain, Samuel Jones and James Foil was authorized to choose an exact site and divide one hundred acres of land into half-acre lots "with convenient Streets, and a Square for Public Buildings." Lots were to be sold for ten shillings and the money collected by James Foil, who was named treasurer. On March 25, Foil was to send money to Mr. Hope Dexter, original owner of the town site, to pay for the land.

Johnston residents received a list of strict guidelines that would be the envy of many modern homeowners' associations. Within two years of obtaining a lot, the owner was to have erected, "a good, substantial, habitable framed house," at least twenty-four feet long by sixteen feet wide. "Leantos" and "sheds" did not qualify. The penalty for noncompliance was loss of land. Furthermore, residents had to keep the underbrush and grasses cleared and have a rail fence enclosing the lot. For those who were lax in their yard work, a penalty of one shilling per month was assessed.

The act also made provisions for establishing inns and boat services at landings on both sides of the river to accommodate travelers heading to

town. In later years, folks would complain of this long boat ride across New River, a distance of over a mile.

In a model of frugality, the assembly directed that the commissioners could feel free to scavenge material from the old courthouse that overlooked Northeast Creek for construction of the new one. This advice, however, was apparently not followed, as when the Onslow justices tried to hold a meeting in the old courthouse site in 1744, they found the structure had been burnt by vandals.

The life of this colonial county town came to a halt in the late summer of 1752. Contemporary accounts of that summer report that the weather had been unusually hot and dry, and on the heels of this a pair of fierce hurricanes roared out of the tropics and waylaid the Carolina coast. The first storm did a great deal of damage in Charles Town. The second was the one that dealt such a devastating blow to North Carolina.

This hurricane skirted along the coast north of Charles Town and hit the New River with all its fury. The storm blew away the town of Johnston, including the courthouse structure and the home of the clerk of the court, Thomas Black. This effectively scattered the official documents and records of Onslow County to the four winds and brought county government to a standstill.

The storm did not just affect inanimate object like buildings and boats. People were caught up in the storm's ferocious winds and whisked away. Legend states that one young child was picked up out of the town and blown all the way across New River. After the storm, the child's parents could not be found, and undoubtedly perished in the storm. The boy was understandably terrified, and when asked his name he merely replied, "Hadnot." He became a ward of the county and was given the name Charles Hadnot. The point where he washed ashore is still known as Hadnot Point.

Onslow County's justices collected taxes to rebuild the edifices of county government, but there was a movement afoot to remove the county seat from Johnston. One reason was because it was no longer centrally located to the growing population of the county. But perhaps the most compelling reason was the long crossing of New River, which was described as "often impassable, very inconvenient to the greatest part of the inhabitants." To make matters worse, the hurricane of 1752 had wiped out the public houses so that travelers had no place to stay when they came to town on business, and no one seemed to be motivated to rebuild.

So in 1755, the general assembly ordered the Onslow justices to use the money already collected for the reconstruction of the courthouse at

## Coastal Rivers

Johnston to build a new courthouse upstream at Wantland's Ferry, the present site of Jacksonville. Nowhere in the act does it say anything about scavenging portions of the old courthouse. The hurricane of 1752 must have left slim pickings.

The law removing the court to Wantland's Ferry repealed the 1741 law naming Johnston the county seat. Soon this ill-fated town faded away, not even being fortunate enough to appear on a contemporary map. James Wimble's map of 1738 was drawn before Johnston was created, while the Mitchell Map of 1755 was prepared after its demise.

Coincidentally, the same year the hurricane destroyed Johnston, Governor Johnston, for whom the town was named, passed away.

NORTH PRONG WHITE OAK RIVER rises in White Oak Pocosin in Jones County and flows southeast to its junction with South Prong White Oak River on the Jones/Onslow line where the White Oak River begins.

SHALLOTTE RIVER rises near Grissettown in Brunswick County and flows in an easterly direction to the town of Shallotte, where the river makes a bend to the south. It continues south until it enters the Atlantic Ocean via Shallotte Inlet, between Ocean Isle Beach and Holden Beach.

The origin of the name Shallotte is uncertain. One theory states that it is named for a variety of wild onion that grows along its banks. Another story states that the river was actually known as the Charlotte River, but was pronounced "Shallote" in the local dialect, and some cartographer wrote down the phonetic spelling as he heard it spoken. Either way, the name is old, as it appears on Edward Moseley's map of North Carolina published in 1733.

There is a belief, originally attributed to the lore of the local Indians who once inhabited the area and passed down to modern times, which states that the waters of the Shallotte are possessed with a mysterious, almost magical curative property. People have been known to travel great distances to obtain a jug of this helpful liquid in order to cure a vast array of ills.

In 1976, Harold Kimsey, then a microbiology student at North Carolina State University, traveled to Brunswick County to investigate the matter. His findings, as reported in the November 1976 issue of *North Carolina Folklore Journal*, stated that the only bacteria-inhibiting material present in the water was salt from the sea near the river's mouth. However, he conceded that more thorough tests were required before a definitive answer could be given.

# NORTH CAROLINA RIVERS: FACTS, LEGENDS AND LORE

The White Oak River at Swansboro.

# NORTH CAROLINA RIVERS: FACTS, LEGENDS AND LORE

There are those who may tend to disagree with such findings. Most who believe in the healing water believe the mysterious ingredient comes from an indigenous reed that is the host to a certain type of mold. The mold is reputed to put off a milky residue, and the tidal action distributes this substance to the surrounding waters.

In 1966, the *Wilmington Star Journal* reported that a local woman believed enough in this mold-infested water to treat her two-year-old son with the liquid. The treatment was a success, and the waters are claimed to have cured an eye problem in the child that physicians had advised would require an operation.

SOUTH PRONG WHITE OAK RIVER rises in the White Oak Pocosin in Onslow County and flows north to meet the North Prong White Oak River approximately seven miles east of Maysville.

WHITE OAK RIVER begins at the junction of South Prong White Oak River and North Prong White Oak River. It winds east/southeast to Maysville, where it takes a more southerly course. Near Maysville, the river flows over a couple of rock ledges that form a series of shoals quite uncharacteristic of rivers in the eastern Coastal Plain.

Following its junction with Hunter's Creek on the Jones/Onslow/Carteret line, the White Oak widens considerably and continues its journey south past the historic town of Swansboro and enters the Atlantic through Bogue Inlet.

Through much of its course, the White Oak serves as the boundary between Jones and Onslow Counties and Onslow and Carteret Counties. Between Maysville and Cape Carteret, it serves as the western boundary of Croatan National Forest.

Early maps, such as John Lawson's published in 1709, refer to this river as the Weetock or Weitock River, in honor of a tribe of Indians of that name who once lived upon its banks.

Otway Burns, a famous naval captain, legislator and man for whom Burnsville was named, grew up along the White Oak River in Swansboro. His statue stands today in his hometown looking out across the waters of the White Oak River.

# Bibliography

Cumming, William P. *The Southeast in Early Maps*. Chapel Hill: University of North Carolina Press, 1998.

Gordon, Nancy, Thomas A. McMahon and Brian Finlayson. *Stream Hydrology: An Introduction for Ecologists*. New York: Wiley, 1992.

Johnson, F. Roy. *North Carolina Indian Legends and Myths*. Murfreesboro, NC: Johnson Publishing Company, 1981.

Lawson, John. *A New Voyage to Carolina*. Chapel Hill: University of North Carolina Press, reprinted 1967.

Mooney, James. *Myths of the Cherokee and Sacred Formulas of the Cherokees*. Nashville, TN: Elder-Bookseller, reprinted 1972.

Powell, William S. *The North Carolina Gazetteer*. Chapel Hill: University of North Carolina Press, 1968.

Rights, Douglas L. *The American Indian in North Carolina*. Winston-Salem, NC: John F. Blair, 1957.

Sharp, Bill. *A New Geography of North Carolina*. 4 vols. Raleigh, NC: Sharpe Publishing Company, 1954–65.

Swain, George, J.A. Holmes and E.W. Myers. *Papers on the Waterpower of North Carolina*. Raleigh, NC: G.V. Barnes, public printer, 1899.

Please visit us at
www.historypress.net